HANLEY
THROUGH TIME
Mervyn Edwards

AMBERLEY PUBLISHING

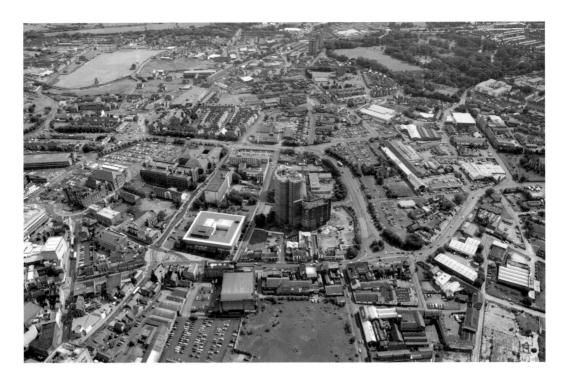

Aerial View of Hanley, 2005

Our book begins with an overview – literally! The most prominent buildings shown here include Unity House, and to the left, the City Library and the Potteries Museum. Some of Stoke-on-Trent City Council's departments were housed in Unity House until 1992 and the building was demolished in 2005. Council employee Paul Edwards told the *Sentinel* newspaper that he had begun work there in 1976 as a planning technician working on the seventeenth of its eighteen floors: 'In a high wind, the building would sway from side to side.' The building's need to be regularly repaired earned it the nickname of Faulty Towers, but its architecture was admired by a discerning few.

First published 2012

Amberley Publishing
The Hill, Stroud
Gloucestershire, GL5 4EP

www.amberley-books.com

Copyright © Mervyn Edwards, 2012

The right of Mervyn Edwards to be identified as the Author of this work has been asserted in accordance with the Copyrights, Designs and Patents Act 1988.

ISBN 978 1 4456 0809 9

British Library Cataloguing in Publication Data.
A catalogue record for this book is available from the British Library.

Typeset in 9.5pt on 12pt Celeste.
Typesetting by Amberley Publishing.
Printed in the UK.

Introduction

In recent years, the town of Stoke-on-Trent has lamented – with much justification – that neighbouring Hanley has enjoyed the lion's share of investment, much to the neglect of Stoke.

However, like it or not, Hanley has been the dominant Potteries town since the early nineteenth century. From being 'a humble collection of dwellings' in the early eighteenth century, it grew into a recognisable town and ultimately emerged as the Potteries metropolis and the city centre that we know today.

Burslem may have been known as the Mother Town, while Stoke-on-Trent was the ecclesiastical hub of the Potteries, the communications centre from 1848 and its power-base from 1910; but if you are making a case for Hanley's pre-eminence among the Six Towns, the question is, 'How much evidence do you want?'

Rough population figures for the six local centres of the Potteries show that until the late eighteenth century, Burslem was the largest town by population, but from 1801 onwards, Hanley was the greatest population centre.

Culturally, Hanley was foremost. The Pottery Subscription Library was founded in Hanley as long ago as 1790. The first Potteries Mechanics' Institute was founded in Hanley in 1825 – one of the first in the country – with premises later built in Frederick Street, and afterwards Pall Mall. The Potteries Museum operates from Hanley today, a successor of Hanley's North Staffordshire Museum – the oldest in the Six Towns -- that opened in the Mechanics' Institute around 1846.

The year after, the first two Potteries Schools of Design were founded – one in Hanley, and one in Stoke. The opening of the Victoria Hall in 1888 confirmed what some people already knew – that Hanley was the cultural and musical centre of the Potteries. As if to emphasise the same, Hanley Park was completed in 1897 – not the first Potteries park, but at 62 acres, the largest.

Politically, Hanley was powerful. It is significant that in 1817, an extremely rare co-operative meeting of the pottery towns agreed that from that point onwards, the head constables of all the towns should meet in Hanley, it being 'the most central place'.

Incidentally, this meeting has been cited as one of the first steps along the road to federation, and I think it is telling that it took place in Hanley. Hanley with Shelton was the first of the local centres to be awarded borough status, in 1857.

Size-wise, Hanley had grown rapidly enough to be considered 'a large modern town' by 1834. And how is a 'city centre' normally defined in present times? Well, it's where we find the main shops. C. Knight recorded in 1847 that Hanley had recently been provided with a range of shops far above the standard of anything else in the Potteries. One of these was Pidduck's, which came to Hanley in 1841, but over the years retail giants such as Huntbach's, Bratt & Dyke's, McIlroy's/Lewis's among others drew shoppers to Hanley.

Let's now turn the pages and find out how our city centre evolved.

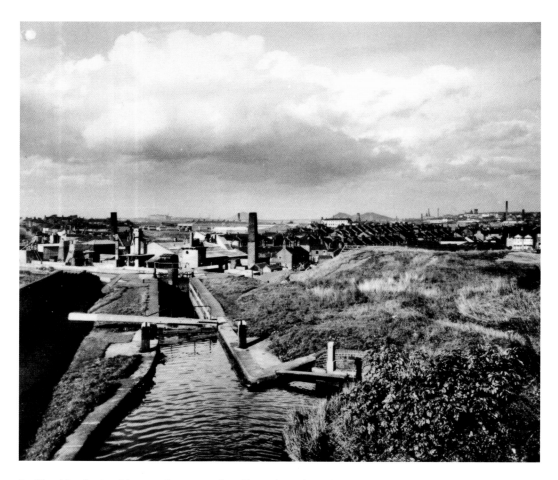

Bedford Locks Looking to the Rear of Mellor Minerals Ltd, Early 1960s
These locks, on the Caldon Canal, are the only staircase locks in Staffordshire. They incorporate unequal chambers due to subsidence. Indeed, the sides of the lock have been regularly raised with layers of concrete on account of this problem.

Lewis's: Santa's Helpers, 1958 and Santa's Grotto, 1973

We begin with a section on Hanley's shops. The young lady (front) is Celia Abbotts, who joined Lewis's at the age of fifteen. She worked in haberdashery and in the food hall, but also had the opportunity of gracing Santa's float, accompanying him on his journey to the store.

For decades, Lewis's department store was a magnet for shoppers at Christmastime, and some people recall that its illuminations almost rivalled those of Oxford Street. Its seasonal celebrations often embraced a theme. For example, in 1960 the store promoted 'the largest and brightest toy fair in North Staffordshire', with Santa appearing in a *Gulliver's Travels*-themed grotto. In that year, Lewis's had hired an LMS locomotive which took Santa the short distance from the Stoke Shed to the railway station at Winton Square. The words 'Father Christmas, Lewis's, Hanley' appeared on the front of the train. In 1963, Lewis's advertised animated models of elephants, clowns, a magician, a sword-swallower and chimpanzees. Toys sold that year included Rosebud dolls, doll prams, toddler trikes and Scalextric motor-racing tracks for the boys. In later years, Santa sailed in a boat across the lake at Trentham Gardens as part of his journey to Hanley. Over the years, other festive themes at Lewis's included *Snow White and the Seven Dwarfs*, *Rupert Bear*, the Ugly Bug Ball and Adam Ant.

In the later photograph, Santa is seen with Philip-John Rowley and his older brother Graham. Their mother Pauline recalls, 'If your child had a photograph taken with Santa, you would be with him for a little while longer, and there was a couple of shillings to pay for the picture.'

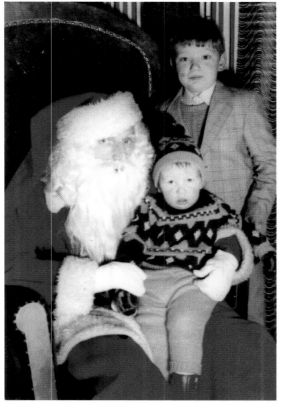

5

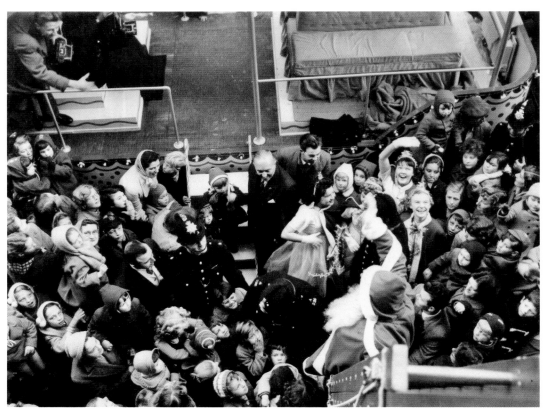

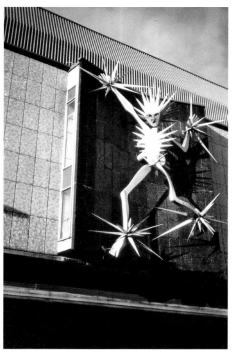

Lewis's & Santa, 1958 and the *Man of Fire*, 1994
Celia is seen waving in this picture, which sees
Santa at the foot of a ladder. She remembers, 'He
would climb up the ladder to get into the store,
watched by the crowds in Lamb Street.' The *Man
of Fire* was designed by London sculptor David
Wynne and appears on the Stafford Street side of
the store. It is made of anodised aluminium and
is 35 feet in height. In years gone by, many young
children being taken to Hanley by their mothers
found it frightening. Adults knew it as 'Jack
Frost'. There is an inscription at the foot of the
statue that reads, 'Fire is at the root of all things
both visible and invisible.' In 2003, the sculpture
was dismantled and taken to Redditch for a
make-over. Predictably, he was missed by many
of the shoppers who recalled being intimidated
by him as children!

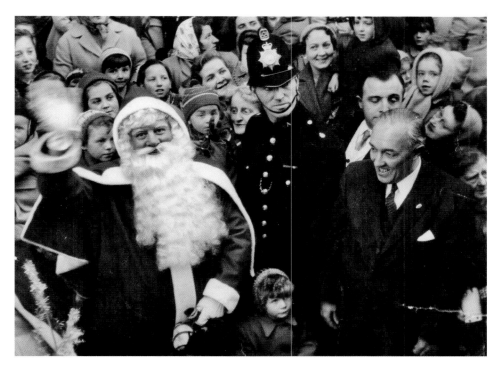

Lewis's & Santa, 1958 and Lewis's, 1998
Santa is pictured here with Lewis's general manager Mr Doughty. The store was absorbed by the Potteries Shopping Centre, opened in 1988. *Sentinel* reader George Heeks, who was involved in the construction, told the newspaper in 2011 that one area of the site, near to Lewis's, was declared off-limits until a pair of blackbirds had raised their young. The colourful murals just inside the Town Road entrance were the work of artist David Light.

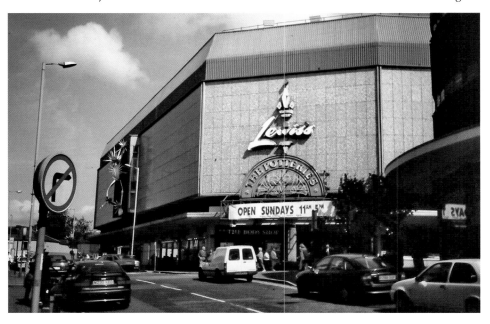

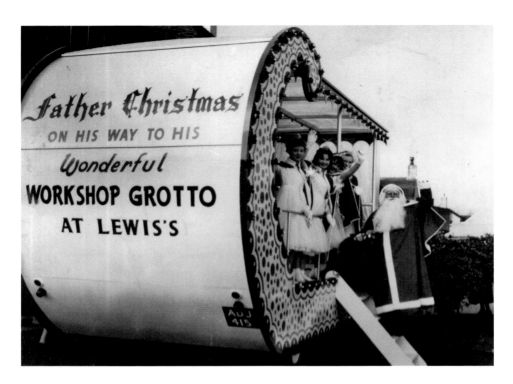

Lewis's & Santa, 1958 and Debenhams, 2012

Celia and her friend wave from Santa's float. One Lewis's tradition lasted for over thirty years and is still remembered. A weekly service for staff was conducted by the resident minister of Bethesda Methodist chapel. It was begun by Rutherford Basham in the early 1950s, the final ones being conducted by the Revd Tony Sutcliffe prior to Bethesda's closure in 1985. The minister also acted as store chaplain, helping staff with personal problems.

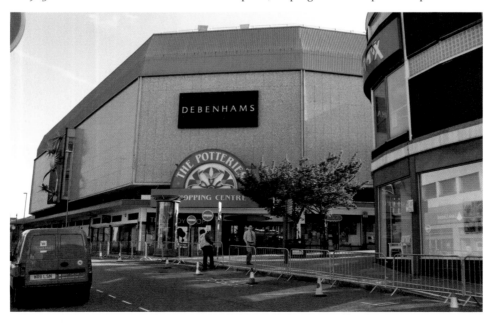

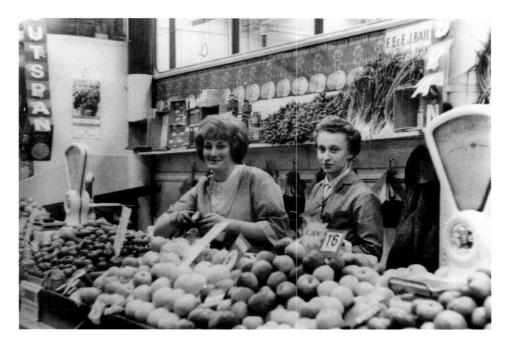

Bailey's in the General Market, 1964 and Barewall Hanley outlet, 2012
Here's an interesting quirk of history. E. E. and E. J. Bailey's fruit and vegetable stall was located in the General Market, and the lady on the left is Mrs Milward. The modern photo was taken inside the building that replaced the old market – the Potteries Shopping Centre. Mrs Milward's daughter Paula – who runs the Burslem-based Barewall Art Gallery with her partner – is seen serving customers on the first day of trading for the Hanley branch, 6 August 2012.

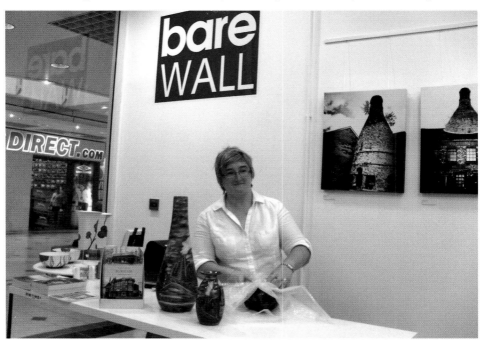

General Market, 1979 and the Potteries Shopping Centre, 1991

A set of stairs in the market led up to what was known as the cockloft. This was a busy gallery, redolent with livestock and pet food. Cats, dogs, cage-birds, ferrets, fish and more were sold there. Customers also purchased bags of broken biscuits and bruised apples. The site is now occupied by the Potteries Shopping Centre, which upon construction elevated Stoke-on-Trent to the status of a regional shopping centre.

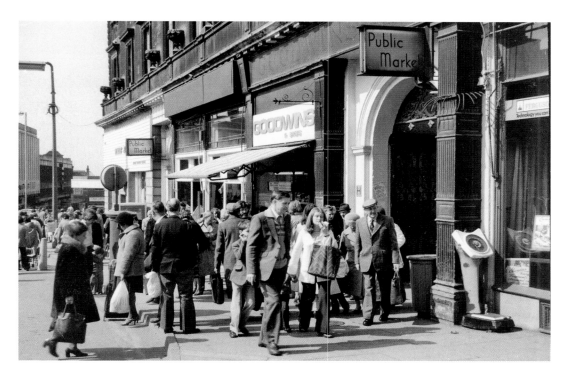

General Market, 1970s and Potteries Shopping Centre, 1994
Traders in the market at various times included the Toffee Kings, run by brothers Eric and Harry Alcock. They sold home-made sweets including treacle toffee and humbugs. A Jack Pointon sold footwear beneath a sign advertising 'the cheapest shoes on earth', while William Vodrey, a bookseller who also sold prints of old masters, is remembered for eating vinegar sandwiches. Dave Barratt sold cheese, butter and bacon from the late 1950s.

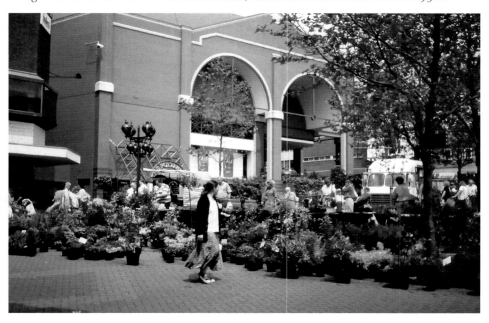

General Market Entrance 1981 Potteries Shopping Centre, 2012

In 1981, the gates of the market were closed for the last time, notwithstanding a valiant campaign by traders to save this Hanley institution. Locally born author John Wain described the market as 'an expression of human life'. Modern thinkers, however, pointed out the outdated interior and its structural defects. It is unlikely that the cockloft would have passed modern hygiene standards! The Victorian building ultimately made way for the Potteries Shopping Centre.

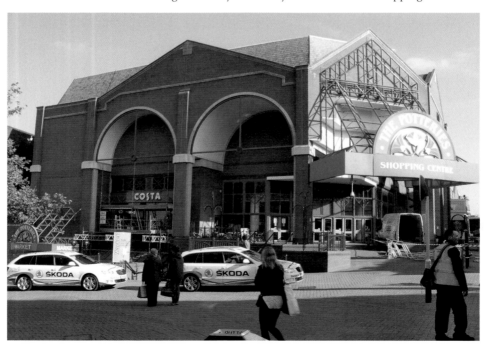

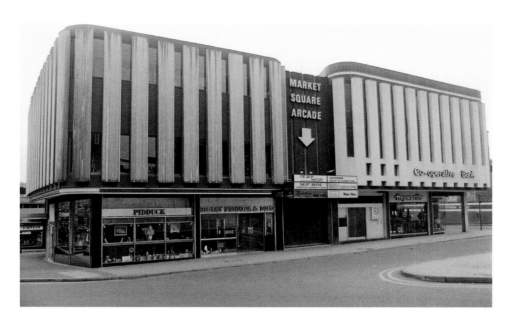

Market Square & Pidduck's, 1970s and Market Square, 2012

Henry Pidduck, born in Shrewsbury, was a jeweller, silversmith, watchmaker and clockmaker who opened his business in Hanley in 1841. Pidduck's name became famous around the world because it manufactured the Blue Riband trophy, awarded for the fastest-crossing of the Atlantic Ocean. Pidduck's old premises in Market Square boasted an octagonal clock, and young lovers often met below it. It was renowned for its accuracy, much to the gratitude of market traders and bus inspectors.

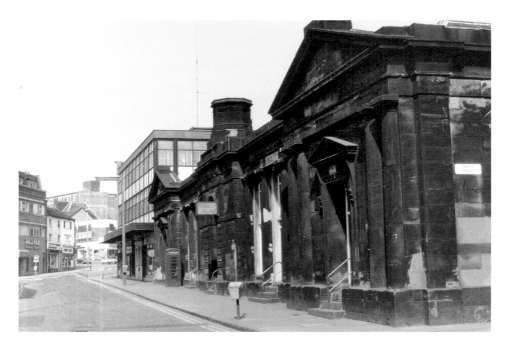

Meat Market, 1970s and the Tontines Shopping Court, 1994

One newspaper correspondent wrote in 1832 about the condition of some of the meat being offered for sale at the new meat market. Some butchers were allegedly procuring cattle at a cheap rate, no matter how unfit for killing and selling. Some of this meat was only sold in the evenings, so that its poor condition was less visible to potential buyers. The building closed in 1987, becoming the Tontines Shopping Court in 1990. It is now occupied by a pub and Waterstones bookshop.

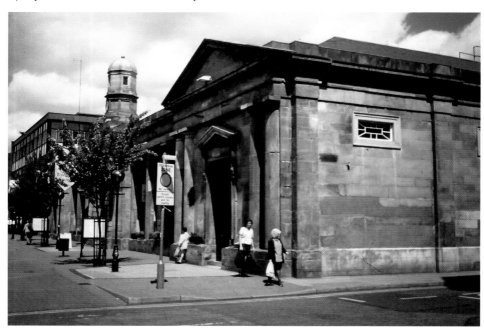

Stafford Street, 1970s and 2012

The grand, domed building at the far end of the street on the colour photograph was, in the early twentieth century, occupied by Teeton's Limited, silk and linen merchants. Ken Smith, now eighty-three, recalls the Port Vale pub in Stafford Street during the Second World War: 'It was a popular haunt for the American forces in the area. Sometimes, there'd be trouble in there, in which case two jeeps would arrive, sirens blaring, and two military police would jump out.'

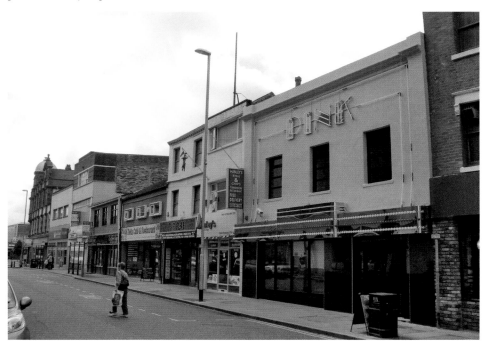

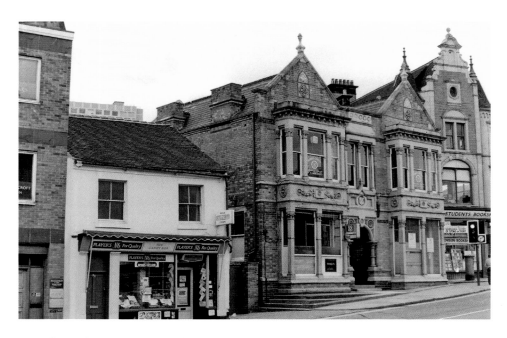

Top of Broad Street, 1970s and 2012
Several impressive buildings in Hanley have survived changing times. By the 1980s, the three-bay brick-and-terracotta building we see here was the headquarters of the National Union of Mineworkers' Power Group, while the turreted building on the right became the RAC's local office and travel centre. The larger building is now occupied by the Airspace Gallery.

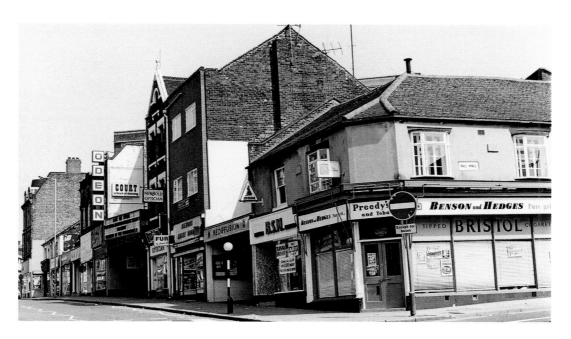

Piccadilly/Pall Mall, 1970s and 2012

The Regent Cinema dominated Piccadilly from 1929, showing films and variety entertainment. It was later renamed the Gaumont, but when the Odeon Cinema in Trinity Street closed in 1975, this cinema assumed its name. In 1989, this cinema closed, reopening as the Regent Theatre in 1999 – a key element in Stoke-on-Trent's cultural quarter. The top photograph advertises the Court School of Dancing, but older readers may remember the Victor Sylvester Dance Studio that opened at the venue in 1957.

Students' Bookshop, 1970s and 2012
This handsome building stands on the corner of Broad Street and Marsh Street South. We are reminded that Hanley and Shelton were once two separate townships and that Hope Street, Piccadilly, Pall Mall and Albion Street all lay in Shelton. Hanley and Shelton achieved borough status in 1857, illustrating the importance of what was then effectively the Potteries metropolis.

C&A, 1991 and Wilkinson's, 2012

C&A in Stafford Street was built on the site of the Essoldo Cinema, closed in 1963. The store opened in 1967, serving Hanley well until fierce competition in the UK clothing market forced its closure in 2001. There were thirty-four redundancies at this branch. Its last manager was Owen Fox, and its longest-serving employee at that time was Gwen Brannon, aged forty-seven, who had been working for the company since she was fifteen. In the foreground of our upper photograph are Ann Rowley and Nick Dutton, who have just been married in the registry office of the Town Hall in Albion Square.

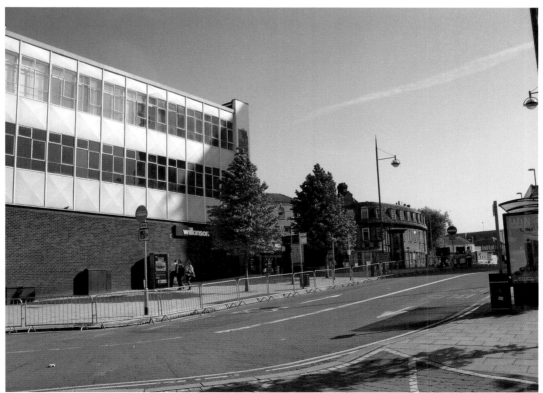

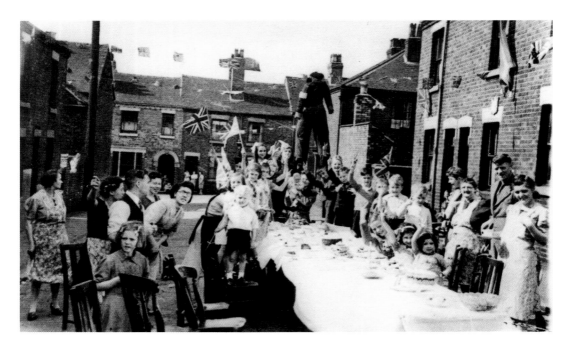

Street Party on Chester Street, Probably End of Second World War and Rosevean Close, 2012
We move on to Hanley street scenes. The sepia photograph shows celebrations in Chester Street. This and other streets in its vicinity – such as Avery Street and Paddock Street – are long demolished. The children living in many of the old houses would play on the local spoil tip, sliding down on sheets of cardboard. Rosevean Close, Malam Street and other new streets occupy this residential pocket of Hanley, a stone's throw away from Waterloo Road.

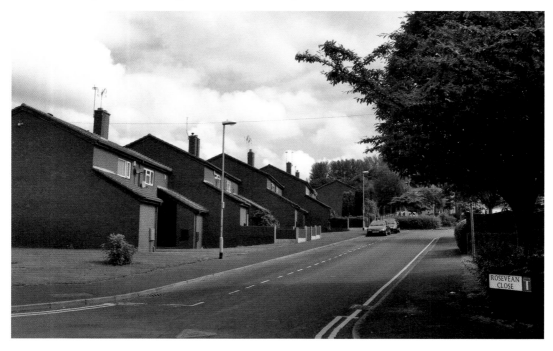

Parkhouse Street/Rectory Street Junction, Shelton, Early 1960s and 2012
Parkhouse Street was named after the Revd Guy Parkhouse, rector of St Mark's church between 1932 and 1959. He was eighty-eight years old upon his retirement. It was during his time (1956) that gravestones, sinking into the turf of the churchyard, were removed. The plaque on the end of the houses reads, '1891. Yew Tree Villas.' Two houses in Rectory Road, directly opposite the mouth of Parkhouse Street, were demolished around July 2012.

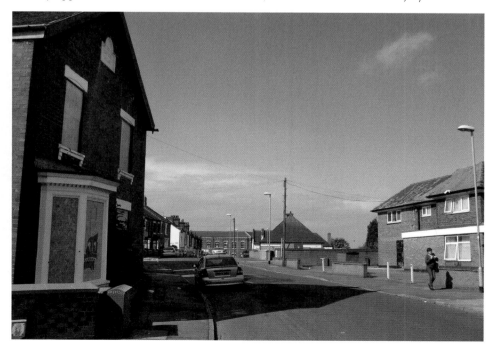

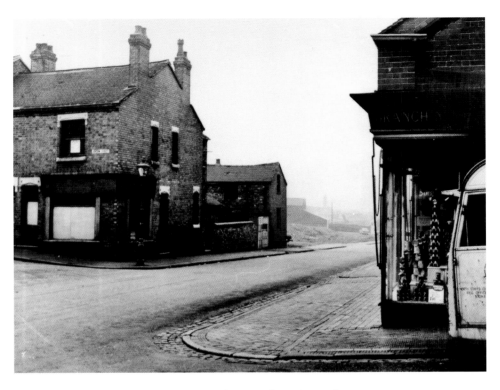

Sun Street/Jordan Street Junction, Shelton, Early 1960s and 2012
Sun Street appears on Hargreaves' map of 1832, the lower part of it being designated Wharf Lane. A co-operative store is in the right foreground of the old photograph, with the Rectory Street waste ground in the distance. Note the blue-brick pavements. The present Sun Street runs on to Etruria Vale Road, where the Bird in Hand pub is to be found opposite.

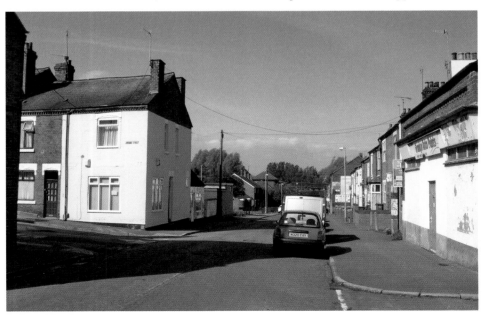

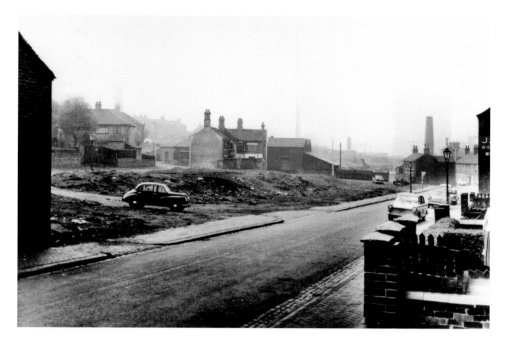

Sun Street Looking Towards Etruria Vale, Early 1960s and 2012
The top picture looks towards the Duke of Bridgewater public house on Etruria Vale Road, showing Mellor Mineral Mills Ltd in the background. On the corner of Timmis Street and Sun Street is 'Wootton's lamp' (to give it its local name). The Wootton family lived in the house on the corner. Behind the industrial chimney on the right is one of the Etruria gas-holders, almost lost in the mist.

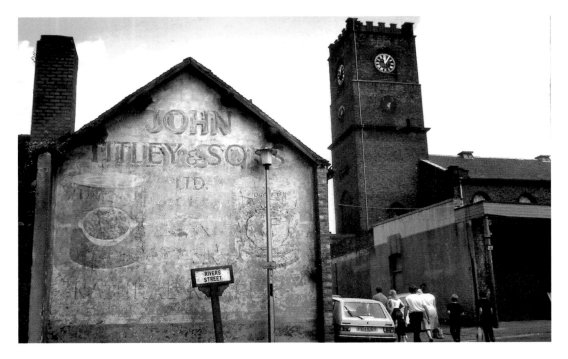

The Slabs/Slobs, 1981 and St John's Church, 1998

The Slabs/Slobs ran from Market Square to Port Vale's Old Recreation Ground, where the club played from 1913 to 1950. The Slabs is named on the 1925 Ordnance Survey map. The top photograph shows people entering The Slabs. It was taken from the end of Swan Passage, at the junction with River Street and Empson Street. The derelict St John's church survives today and in our 1998 photograph stands next to the Potteries Shopping Centre. The Slabs is no more.

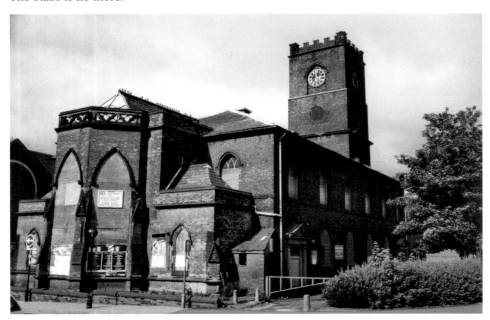

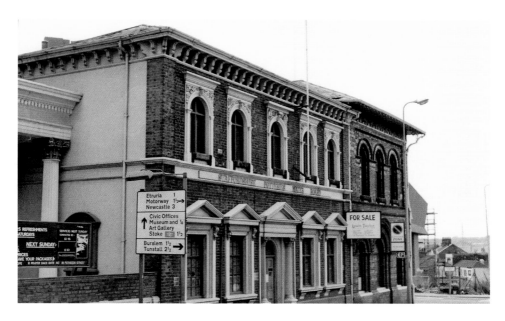

Staffordshire Potteries Water Board Offices, 1970s and Former Offices, 2012
The first offices of the Staffordshire Potteries Waterworks Company were set up in Lamb Street in 1847. However, in 1858 the company moved to purpose-built premises in Albion Street, next to the Bethesda chapel. The building on the corner of Albion Street and Bethesda Street was erected for the Potteries Central Savings Bank. The necessary expansion of the company's operations in the second half of the nineteenth century triggered the extension of its premises into the bank building in 1889.

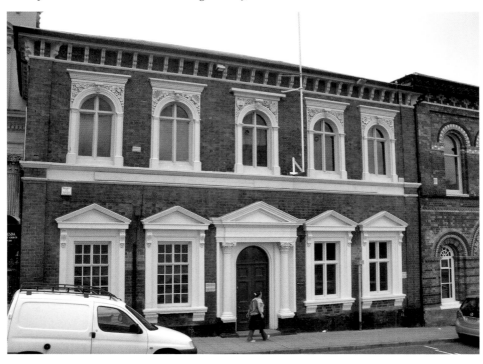

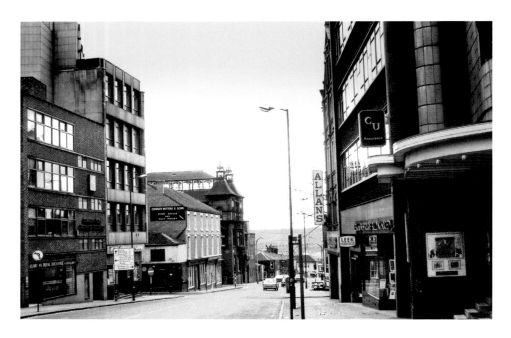

Trinity Street Looking Towards Etruria, 1975 and 2012

The dominant feature of both photographs is the former Telephone Buildings on the corner of Trinity Street and Marsh Streeet South – now the Fat Cat café-bar. June Gilby began working as an operator at the telephone exchange in 1944. Her employers were strict. She told the local press in 1999, 'You couldn't make personal calls, you had to ask to use the toilet, you were even told not to cross your legs while sitting at your desk.'

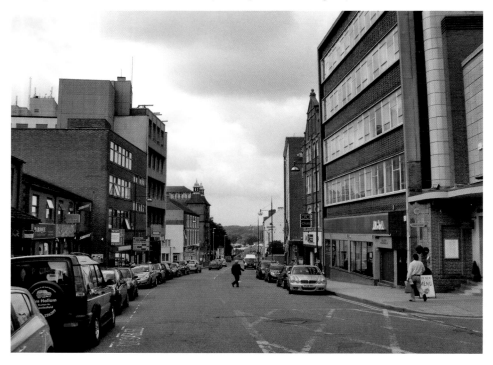

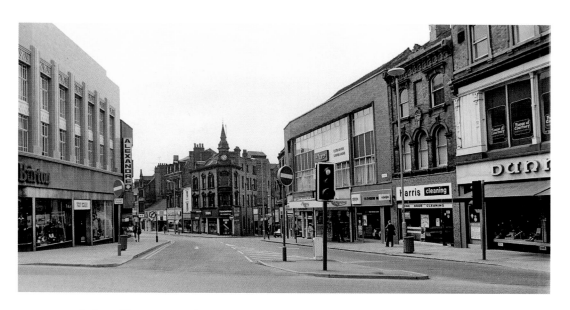

Top of Piccadilly, 1970s and 2012

Electric trams, phased out by the late 1920s, formerly ran along Piccadilly. The spired building in the middle of both photographs has remained a Hanley landmark. In the early twentieth century, these premises were occupied by Boots Cash Chemists, but by the time our top photograph was taken, Visionhire TV Rental was trading there. Early twentieth-century photographs show Burton's with a grandiose frontage, carrying the invitation, 'Let Burton's dress you.' The shop later became JJB Sports.

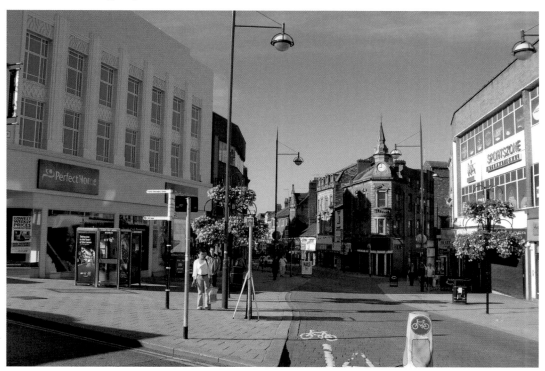

Hope Street, 1984 and 2012

Numerous readers of the *Sentinel* newspaper have written in to describe Hope Street's many shops. Over the years, they have included Chawner's gents' outfitters, Goodwin's the jewellers, Brown's the chemist, and Chatfield's music shop, which was at the top. It sold instruments, albums and sheet music. Barbara Jeffries, from Kidsgrove, described 'Hope Street Walking', when teenage girls, dressed in their Sunday best, would walk up and down Hope Street hoping to meet boys.

Top of Trinity Street, 1970s and 2012

The former Bratt and Dyke emporium on the extreme left was opened on 26 June 1897 and was designed specially to show off the goods within. The architect was Elijah Jones, and the builder was T. Godwin, whose firm also erected the Grand Theatre and the Victoria Hall. The work was superintended by Oliver Dyke, and the premises, upon opening, were known as The Central. The company advertised themselves as drapers and milliners, selling dresses, jackets, lace goods, etc.

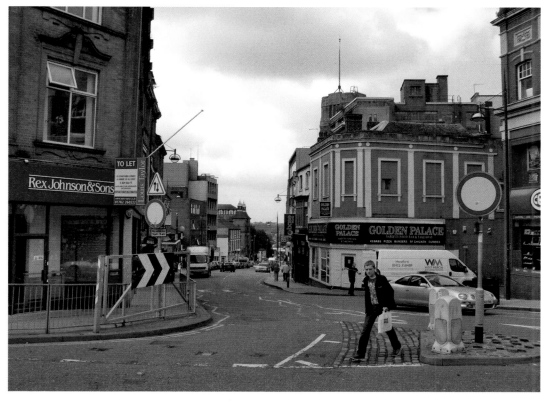

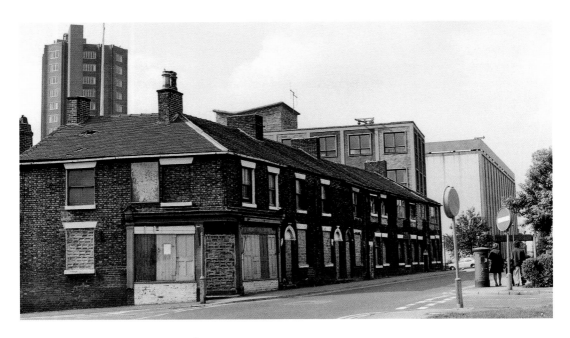

Bethesda Street, 1970s and 2012

The two pictures include the City Central Library, which was officially opened on 10 December 1970. In the present library entrance is a plaque recalling Alderman Horace Barks OBE, a councillor who is remembered in the name of the Horace Barks Reference Library in the building. A voracious reader and a chairman of the Libraries and Museums Committee, he was also a founder of the North Staffordshire Esperanto Club. He died in 1983, aged eighty-seven.

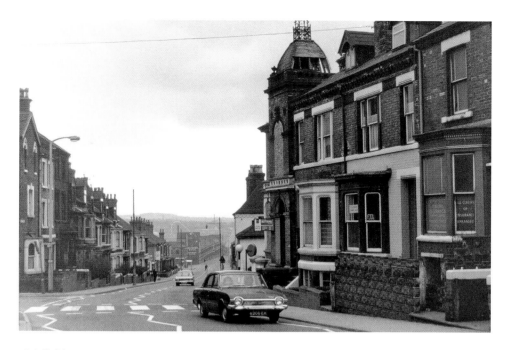

Lichfield Street, 1970s and 2012

Thomas Hargreaves' 1832 map shows very little housing and industry around upper Lichfield Street – but it grew rapidly in the nineteenth century, with the Eastwood Brick and Marl Works being established nearby. However, in 2001, City Council environmental health officers made a survey of 190 properties in the streets radiating off Lichfield Street, finding that 65 per cent of the homes were unfit for human habitation according to the 1985 Housing Act's criteria. Much demolition has followed.

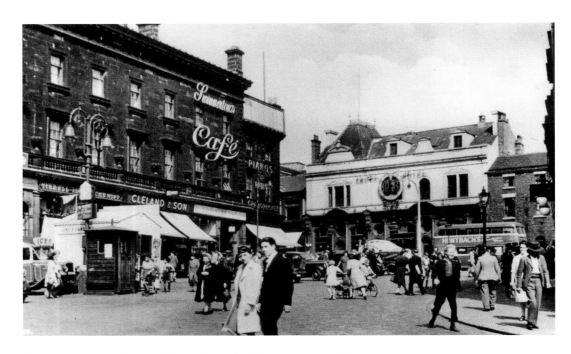

Market Square and Angel, Early Twentieth Century and 1984

In 1872, Bostock and Wombwell's menagerie performed in Market Square. During the course of the show, it was necessary to take some camels and an elephant to the Angel Hotel's stable-yard. Some curious children spotted their opportunity to feed the elephant nuts 'and other things'. The elephant, having been fed stones, became angry and seized a boy named Stanton with her trunk, crushing him against a wall before dropping him to the ground. He later died from his injuries.

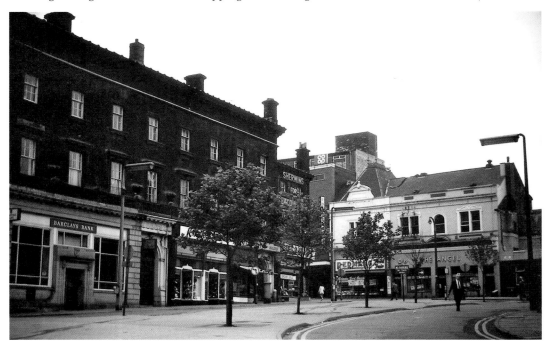

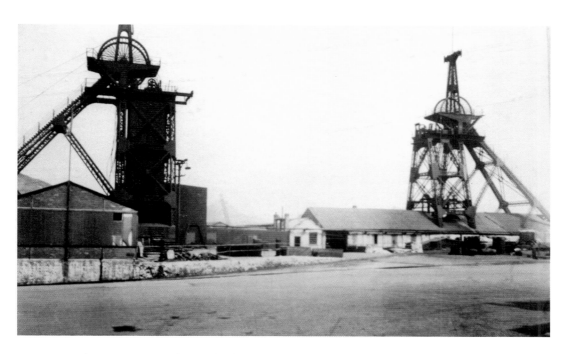

Deep Pit, Late 1940s and Pit Wheel, Central Forest Park, 2012
What of industry in the town? Coal mining was well established in Hanley before the Hanley Deep Pit was inaugurated in the mid-nineteenth century. It is recorded that in 1804 the Hanley and Shelton Colliery was producing 1,200 tons of coal weekly. Hanley Deep Pit was situated on Town Road, Hanley. The pits were sunk by Lord Granville in the 1850s. In 1868, the workforce numbered 400 men and boys and about 400 tons of coal was mined each day.

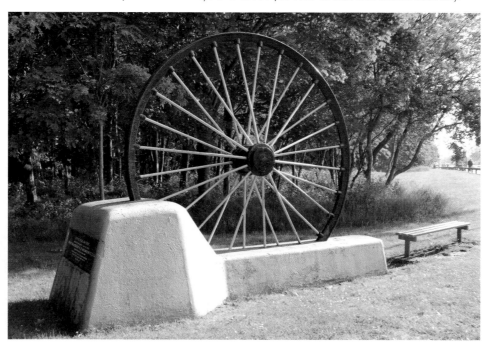

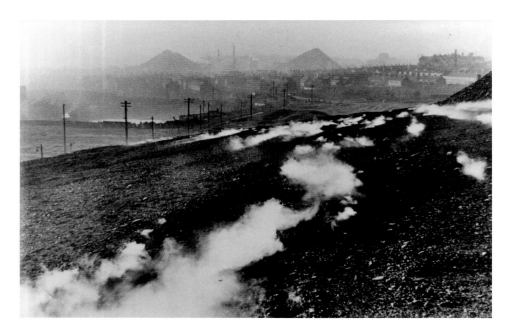

Deep Pit Spoil Tip, *c.* 1960 and Central Forest Park, 2012
Deep Pit Colliery was sunk to a depth of 1,530 feet by 1872 and was reputedly the deepest coal mine in the Midland counties even at this time. The shafts were deepened and widened in 1901, the depth becoming 2,661 feet. Deep Pit was connected by private railway to the Shelton Steelworks at Etruria and was also linked with the North Staffordshire Railway Potteries Loop Line. In 1947 the saleable output of the colliery was 350,114 tons, while 1,285 men were employed.

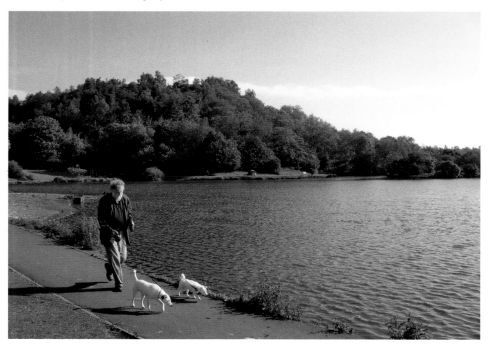

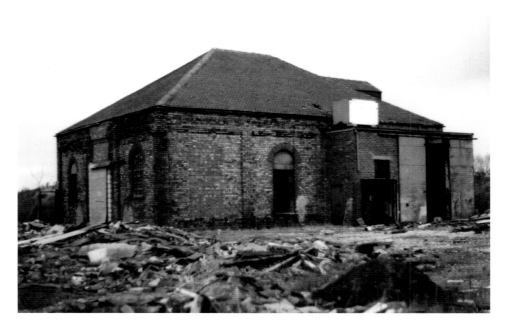

Deep Pit Colliery Winding Engine House, 1994 and Central Forest Park, 2012
Hanley Deep merged with Wolstanton Colliery in 1962 and the surface was closed in May 1962. Demolition work was slow to begin, but much of it was done in August 1964. Several old buildings survived for years, as our photographs show. The 80-acre site became part of Central Forest Park, an award-winning reclamation scheme that topped the urban land reclamation section of the 1971 conservation awards scheme.

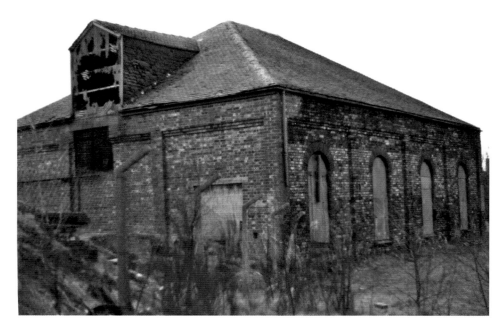

Deep Pit Winding Engine House, 1994 and Central Forest Park, 2012
Central Forest Park was opened in May 1973 by Her Majesty the Queen. From the beginning, the park was intended for walking, cycling, riding and informal recreation. One long-distance walker, Keith Meeson, called at the site in June 2005 during his sixteen-hour, 60-mile Treetops Trek Walk. He visited the former site of every North Staffordshire Colliery that had been working fifty years previously. Proceeds from this charity event went to the Donna Louise Trust.

Deep Pit Offices, 1994 and Central Forest Park, 2012
The history of Central Forest Park has not been without controversy. In 1995, Stoke-on-Trent City Councillors, under pressure from the Save Our Forest Park action group, threw out proposals to build what would have been a third campus for Stoke-on-Trent College on part of the site. The park would have lost 3.9 acres to the scheme, which was also opposed by the Staffordshire Wildlife Trust.

Deep Pit Offices, 1994 and Central Forest Park, 2012

In 2008, it was announced that the park had won two design awards, following its re-landscaping and improvement work. Features included the largest skateboarding plaza in Europe and an eye-catching metal tree, which has symbols of the city hanging from its branches. Entitled *Tree Stories*, it was unveiled in January 2008. The artist, Denis O'Connor, was also responsible for *Privilege*, located in Etruria.

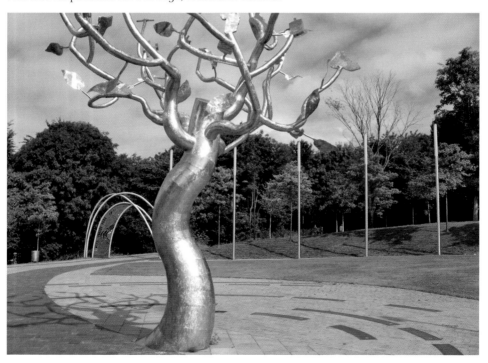

Etruria Hall, 1980 and 1993

Etruria Hall was built between 1768 and 1771 to the north-east of Josiah Wedgwood's Etruria works. Designed by Joseph Pickford, it was conveniently near to his business, but screened from his pottery by a plantation of trees. The need for increased accommodation necessitated the construction in 1780 of two wings, each with two stories. Pictured are North Staffordshire visitor guide Bryn Jones (as Wedgwood) and Lord Mayor Marian Beckett, launching a Wedgwood-themed car cassette tour.

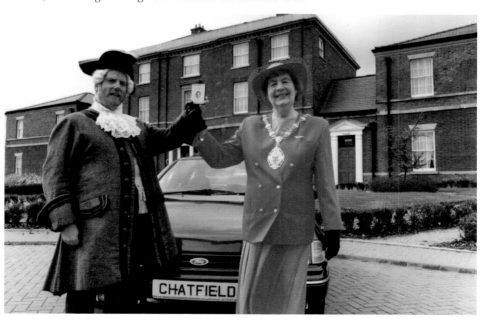

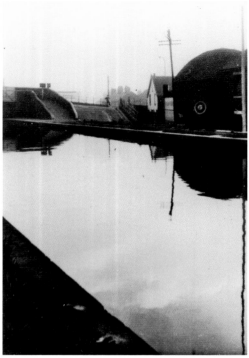

Roundhouse from the Trent & Mersey Canal, *c.* 1962 and 2012

The Roundhouse is all that remains of the Etruria Works of 1769. Production continued on site up until 1940, when Wedgwoods relocated to Barlaston, and the last of the factory buildings at Etruria was demolished in the mid-1960s. The original use of the Roundhouse is a mystery. It may originally have been a hovel, subsequently converted. One theory suggests that Wedgwood conducted engine experiments in it. Local people remember the Roundhouse being used as a stable for bargees' horses. There is said to have originally been a Roundhouse at each end of the factory, one apparently having been used as a store and a lock-up for the factory's manual fire engine.

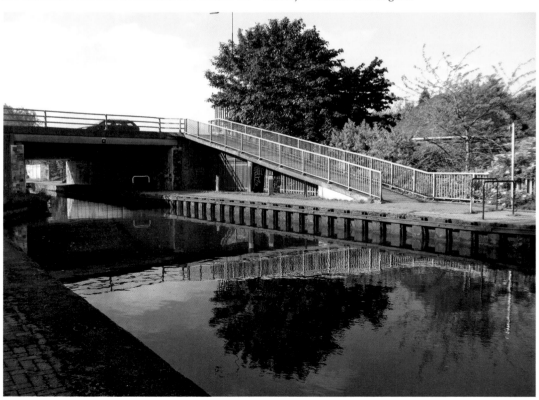

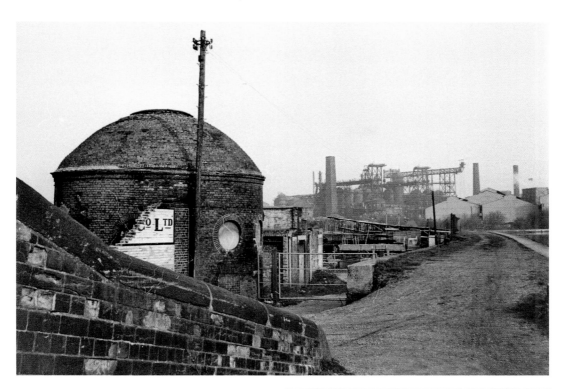

Roundhouse, 1970s and 1994

Like all businessmen and like all visionaries, Josiah Wedgwood realised that everything connects to everything else. He wrote to his business partner, Thomas Bentley, in 1766: 'As to my private concerns I have almost forgotten them. I scarcely know without a good deal of recollection whether I am a Landed Gentleman, an Engineer, or a Potter, for indeed I am all three & many other characters by turns.' The enigmatic Roundhouse has sunk several feet below the level of the Trent & Mersey Canal on account of subsidence. In fact, both the factory frontage bordering the canal and the Roundhouse had slumped 12 feet below the 'Cut' by 1960. The front elevation of the factory came to be depicted by Alf Wakefield and other artists. The headquarters of the *Sentinel* newspaper now stand next to the Roundhouse, which became a small museum of printing and ceramics.

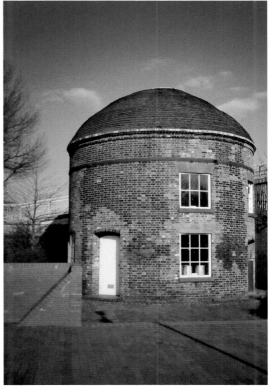

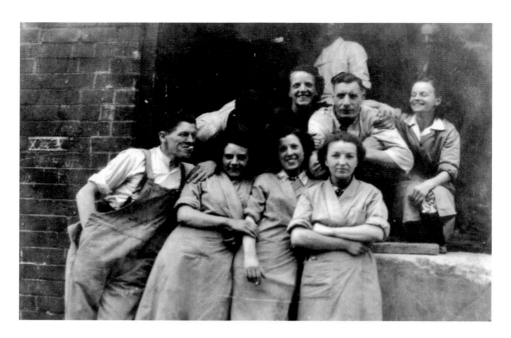

Wood's Tileries, *c.* 1953 and Ogden Road, 2012

Ogden Road survives and is to be found off Regent Road in Hanley. Bob Adams of Tunstall relates that every year, Wood's Tileries arranged a company day-trip – often to New Brighton. It took place on Sundays, as the firm worked a five and a half-day week. A photograph in Bob's collection sees workers gathering 'ready for the off' next to their privately hired Baxter's bus.

Wood's Tileries, Late 1950s and Ogden Road, 2012

Bob's father, Percy, worked at Wood's for around thirty years, finishing in the mid-1960s when it closed. Percy was a mould-maker/modeller who cycled to work from his home in Gordon Street, Burslem. He later worked at Price and Kensington's in Longport. Bob recalls of his father, 'He always said to me that the potters would never get good wages because the workforce was women-dominated – and with many women being housewives, a lot of them were part-time. Some women well into their eighties would take on paid part-time work for one afternoon a week, stamping patterns on ware.' Bob himself worked at the Midwinter Pottery in Burslem in 1962, before joining the Michelin tyre company in 1964 and securing better wages.

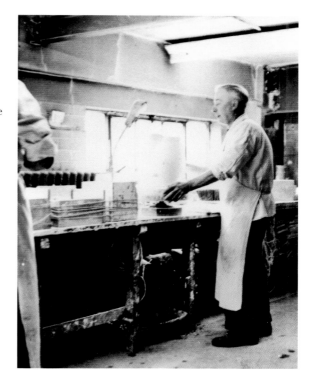

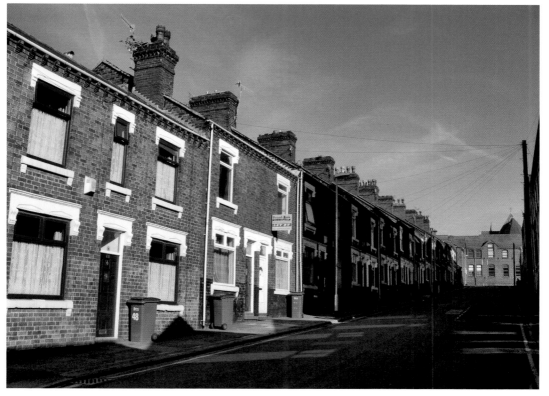

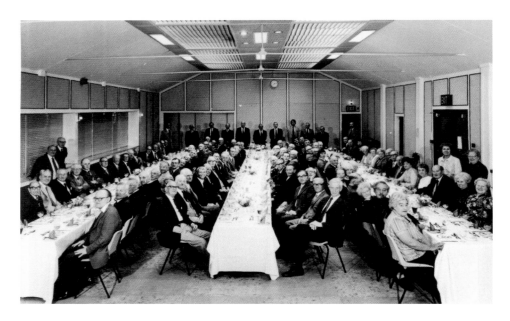

Twyfords OAPs Function, 1980s and Their Cliffe Vale Works, 2012

The name of Twyford became synonymous with sanitary ware, and was already well-established before this model factory, the Cliffe Vale Pottery, appeared in 1887. The new factory's toilet facilities and systems of ventilation were regarded by Government inspectors of factories as a pattern for the whole of Staffordshire. The magnificent factory frontage has been carefully preserved by Countryside Properties, who unveiled the Twyford Court apartments to the rear in 2008. Two bottle ovens, overlooking the nearby canal, were also refurbished.

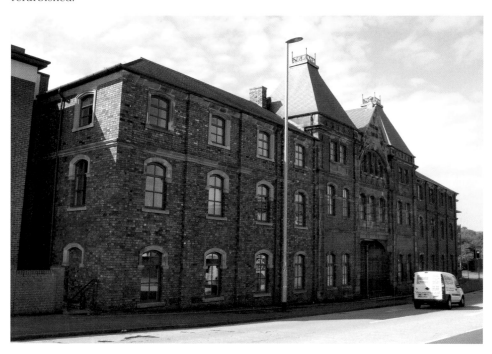

Twyfords Employees, 1983 and Their Cliffe Vale Works Extension, 2012
The top photograph shows company employees director Terry Henwood and Marie Haywood. She joined in 1960 as a lathe worker in the engineering production department, helping to make brass taps and bolts. She moved in 1971 to the firm's publicity department, looking after reps and parcelling catalogues. She retired in 1980, and died in 2008, aged eighty-eight. Her husband Arthur, son Trevor and sister Gwynneth Edwards (*née* Bayliss) all worked at Twyfords in Cliffe Vale.

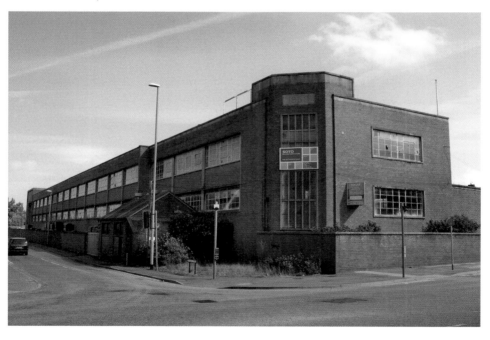

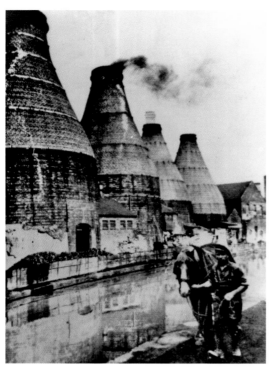

Meakin's Pottery, *c.* 1953 and Emma Bridgewater Factory, 2012
J. and G. Meakin's Eastwood Pottery fronted Lichfield Street, but here we see the Cauldon Canal running alongside the premises. Brothers James and George Meakin had launched their pottery partnership in Hanley in 1851, and the factory seen here was built in the 1880s. At the time of J. and G. Meakin's centenary in 1951, the company was headed by Bernard Meakin, who served as company chairman for twenty-eight years until he retired at the age of seventy. He had also been a Staffordshire County cricketer. The centenary celebrations were held at the Ivy House sports ground, and featured a coach-and-pair, employees in nineteenth-century costume and a dancing troupe.

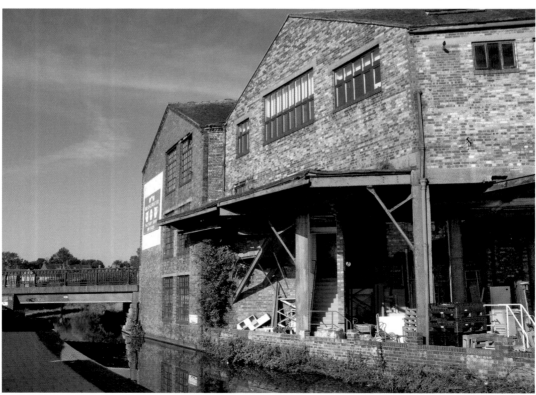

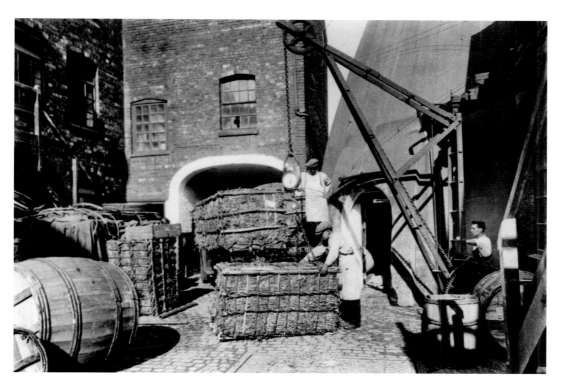

Dudson Brothers, Date Unknown and 1994
Dudson's is the oldest surviving family business in the ceramic tableware industry. Richard Dudson began trading in 1800 at the Broad Street Works in Hanley, and from 1809–45, Thomas Dudson operated the new Hope Street Works, also in Hanley. James Dudson and J. T. Dudson were to subsequently leave their mark, before the company traded as Dudson Brothers from 1898 onwards. The sepia photograph shows the process of packing ware in crates of straw.

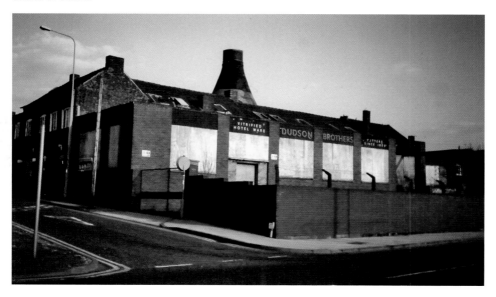

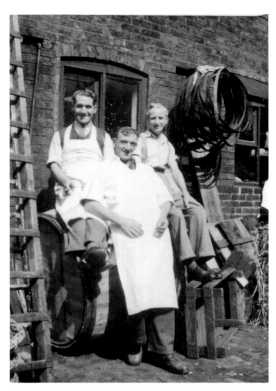

Dudson Brothers, Date Unknown and Dudson Museum, Recent

One anonymous letter-writer to the *Potters' Examiner* newspaper in 1846 made lacerating remarks about James Dudson. He wrote, 'There is an individual, who resides in Hope Street, who glories in the name Manufacturer, and who has gotten fixed up in his workshop an apparatus called a whispering pipe, by which means he can sit in his room and listen to every word that is spoken by his workpeople.' In fact, Dudson had merely fitted a speaking tube between his office and the workplace in order to facilitate communication.

He was so incensed that he offered an enormous £1,000 reward for the identity of his critic. The gentlemen in the photograph are Charlie Lester, Jack Bentley and Bill Williams.

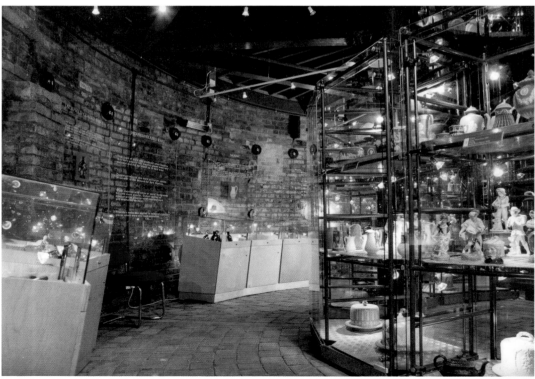

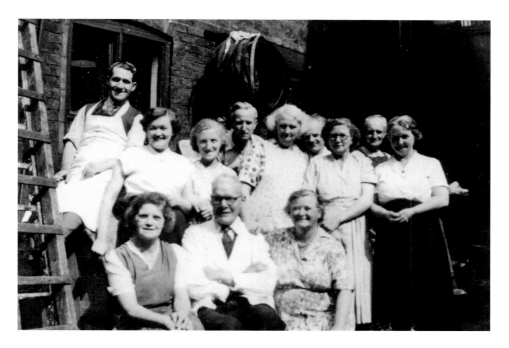

Dudson Brothers, Date Unknown and Dudson Museum, Recent

A trade journal of 1893 describes J. T. Dudson of the Hope Street Works as a manufacturer of earthenware, white and coloured stone bodies and jasper ware. Among the items specifically mentioned were his tea and coffee pots, flowerpots, spittoons, beer sets, candlesticks, vitreous stoneware mortars and pestles, Jasper flower and art jugs and toast racks. Here's a group shot of Dudson's workers posing for the camera.

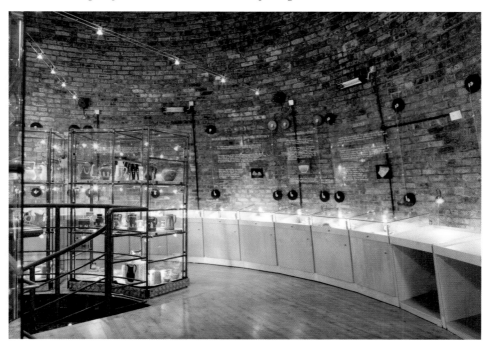

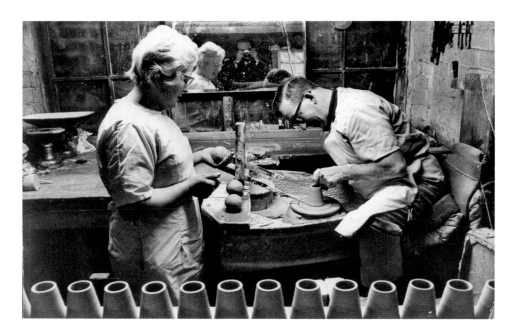

Dudson Brothers, Date Unknown and Dudson Museum, 2012
The factory only three bottle ovens; one is clearly shown on the 1898 Ordnance Survey map, which shows the factory standing on the corner of Hope Street and Hanover Street. The kiln survived and became Grade II listed in 1979. It is now a museum housing the impressive Dudson pottery collection. The other two kilns were demolished after the Clean Air Act of 1956. The rest of the Hope Street site is now used as a community and conference centre. Reg Kear and his wife Madge are seen at work in the upper photograph.

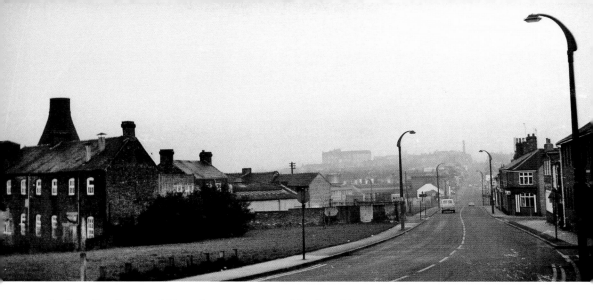

Dudson Brothers and Hope Street, 1970s and Dudson Museum, 2012
The museum was the brainchild of Audrey Dudson, a seventh-generation descendant of the company's founder. There is a small café adjacent, across the courtyard. The Dudson Group continues to this day, under the auspices of the eighth generation of the Dudson family. It specialises in the production of wares for the worldwide hotel and restaurant market.

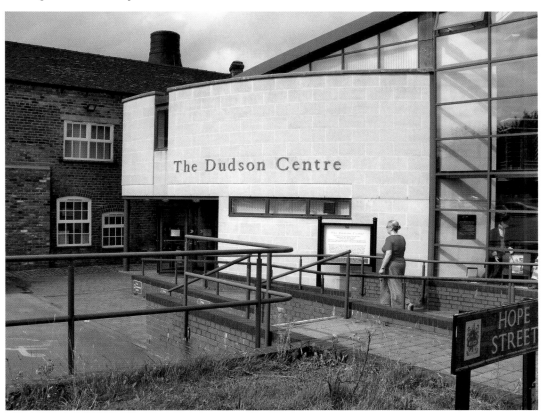

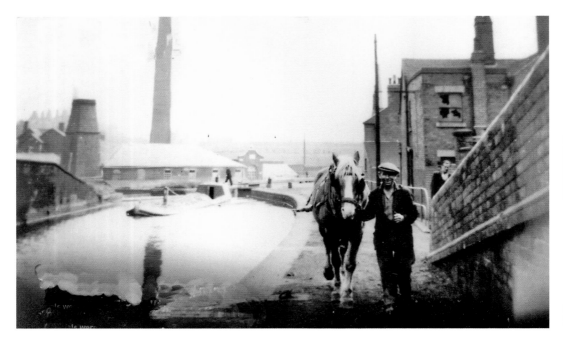

Shirley's Bone & Flint Mill, 1950s and Etruria Industrial Museum, 1993
The Etruscan Bone and Flint Mill was built in 1857 to grind raw materials for the pottery and agricultural industries. These variously included animal bone, flint and Cornish stone, nitrates and Peruvian guano. The fellow in the sepia photograph is Ernie Gorton, known as Ernie Wood when he worked on the boats. North Staffordshire visitor guide Peter Green is seen with customers, including Derek Barnard on the left.

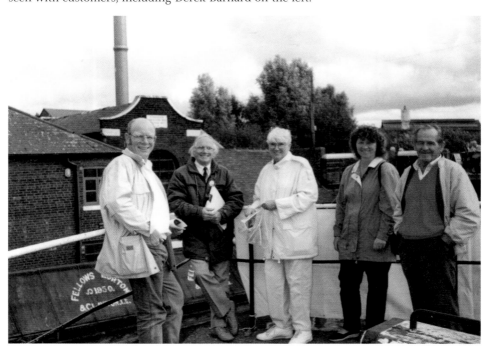

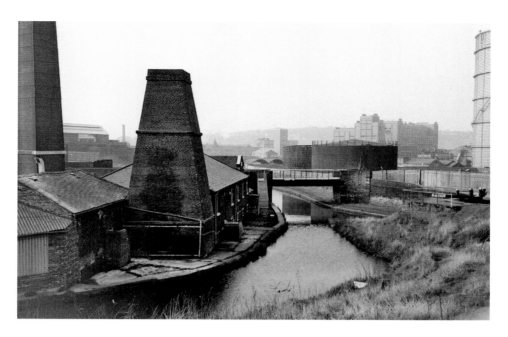

Shirley's Bone & Flint Mill, 1970s and Industrial Museum, 2009
The mill ceased production in 1972 but was scheduled as an Ancient Monument in 1975. Since 1978, a team of volunteers has worked a few hours every week to restore and maintain the mill. *Princess*, a double-acting, condensing beam engine, was restored to steam in 1990 and is a big draw for visitors to the annual Etruria Canals Festival, centred around the mill.

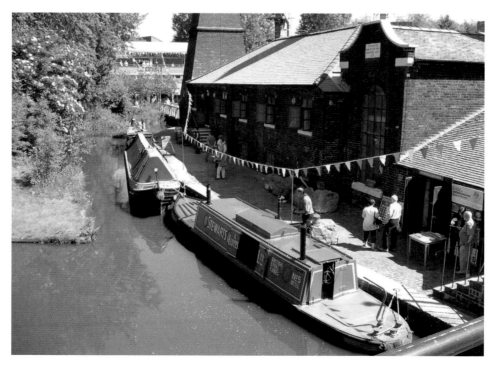

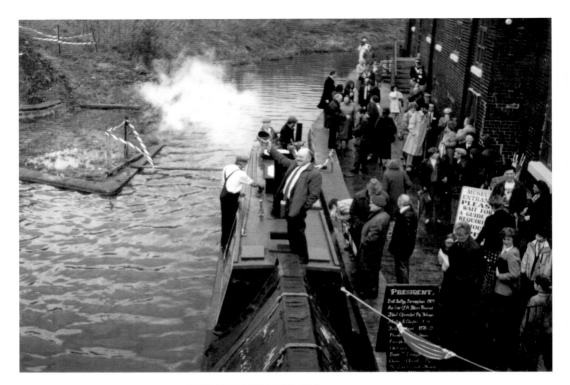

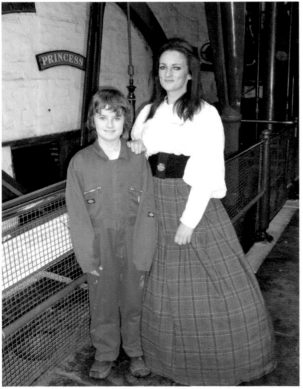

Etruria Industrial Museum, 1991 and Volunteers, 2012

The Etruria Industrial Museum at Shirley's Bone & Flint Mill was officially opened by Sybil Halfpenny, the Lord Mayor of Stoke-on-Trent, and Television and radio personality Fred Dibnah on 6 April 1991. The famous steeplejack made a short, off-the-cuff speech for the occasion. Volunteer Jack Fowler-Evans – a self-confessed fan of the late Dibnah – is seen here with his mother Danielle, in period costume. They and their colleagues have something of a reputation to uphold, as their predecessors won the Dorothea Award for Conservation back in 1985. *Princess* is reputed to have been manufactured by the firm Bateman and Sherratt of Salford and may date from 1820. Unusually, no maker's plate has been found on the engine, hence the uncertainty. It is believed to be the world's oldest driving engine still *in situ*.

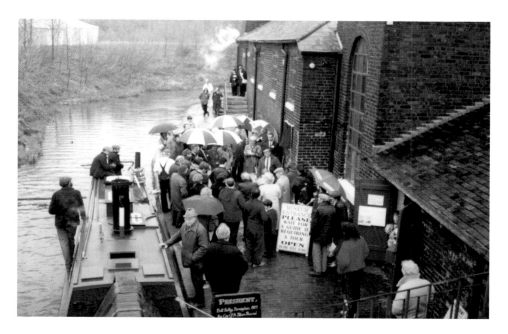

Etruria Industrial Museum, 1991 and Cornish Boilers, 2012
The Cornish boiler at the museum had been made locally in 1903 and was installed in the swimming baths in Tunstall's Jubilee Buildings in that year. It was brought to the museum in 1989 as a replacement for a Lancashire boiler, with the aim being to restore *Princess* to full working power. It was lit for the first time at Etruria in July 1990 and has been most successful, as well as an attraction in its own right.

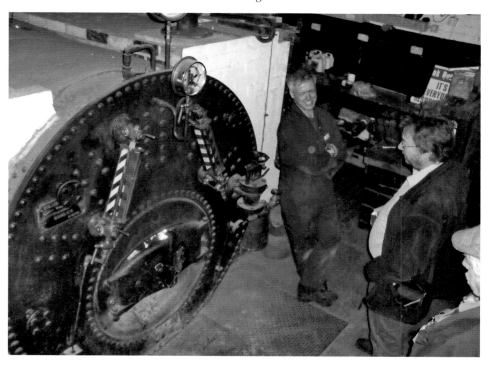

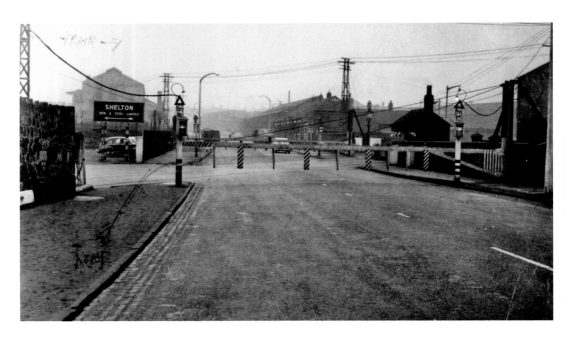

Shelton Iron & Steel, 1960s and Former Site, 1994

People once marvelled at the crimson sky over industrial Etruria – a setting that H. G. Wells used for his story, *The Cone*. He wrote, 'A blue haze, half dust, half mist, touched the long valley with mystery ... Nearer at hand was the broad stretch of railway, and half invisible trains shunted – a steady puffing and rumbling, with every run a ringing concussion and a rhythmic series of impacts, and a passage of intermittent puffs of white steam across the further view.'

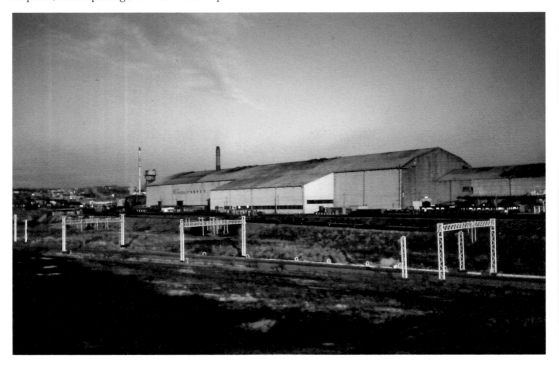

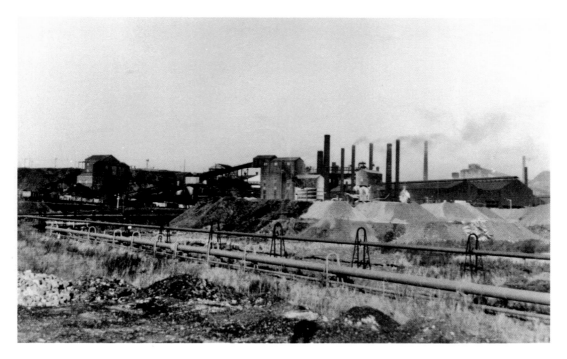

Shelton Iron & Steel, *c.* 1961 and Former Site, 1998
The blast furnaces, chimneys and slag heaps of 'Shelton Bar' dominated Etruria until iron and steel making at Shelton ceased in June 1978. The rolling mills remained on site, and the crashing noise that emanated from them persuaded May Bank and Wolstanton residents to complain to British Steel in 1995. The mills closed in 2000 with the loss of 300 jobs, and were demolished in 2004. The last remaining chimney on site was demolished in 2005.

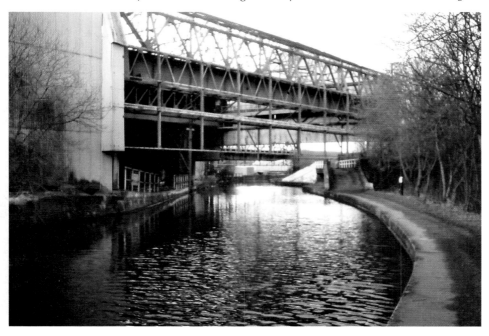

Etruscan Choral Society Singers, *c.* 1958 and Salem Street, Etruria, 2012
Our section on culture and entertainment begins with a photograph of Etruscan Choral Society singers, pictured at the Llangollen eisteddfod. Pam Brindley (later Dutton) is on the far right. The society's base, from 1945, was the Etruscan Philharmonic Hall in Humbert Street, later known as the Kathleen Ferrier Hall. It was closed in 1973 and later demolished to make way for the A500. The modern photograph shows Salem Street in the foreground, and an Etruria that has changed beyond recognition.

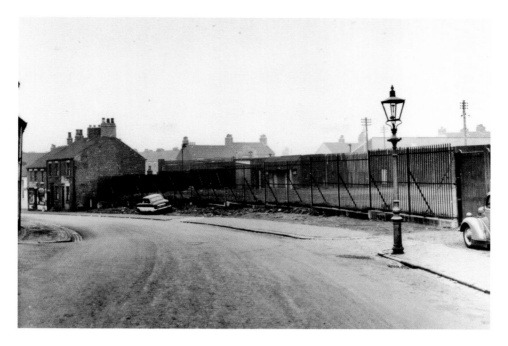

Sun Street Stadium and Car Park, Early 1960s and Site in 2012

Greyhound racing came to Hanley in 1928 with the establishment of a stadium in Sun Street. The stadium was damaged by an incendiary bomb attack during the Second World War. Over the years, greyhounds that ran included Trentham Boy, Jolly Collier, Minerva, Shining Hour and Light Jester. In the post-war years, bookmakers such as Tom Donoway and Alf Davies took the bets. Midget car racing, cycle and motorbike speedway, stock car racing, boxing bouts and even athletics were all staged here.

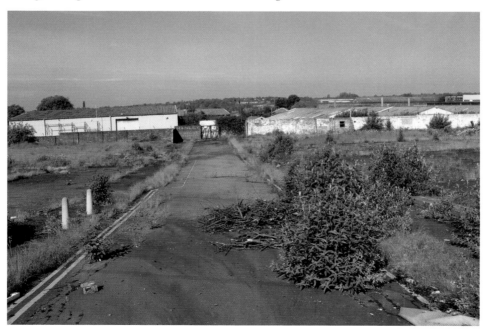

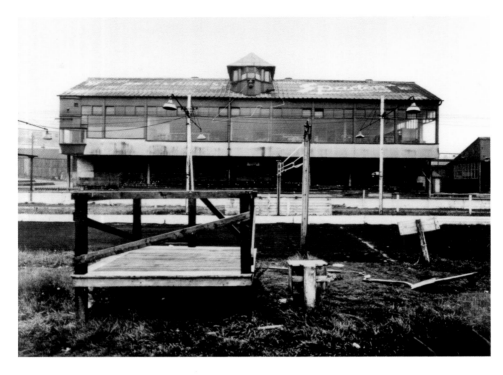

Sun Street Stadium, Early 1960s and Entrance, 1994
The late, great John Abberley often wrote about Sun Street in his nostalgia columns in the *Sentinel*, having watched the speedway in the late 1940s and early 1950s. John wrote, 'The top Stoke riders were like pop stars. I can reel off the names without hesitation. Les Jenkins, Dave Anderson, Dickie Howard, Gil Blake, Vic Pitcher, Reg and Ray Harris. They were their own mechanics. These were sporting gods with dirty hands.'

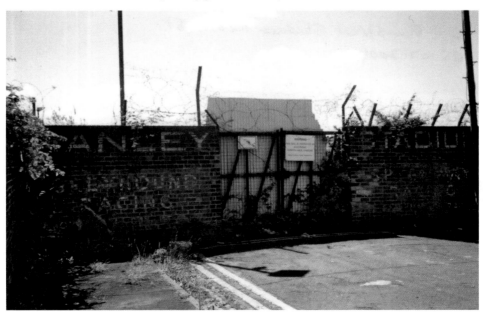

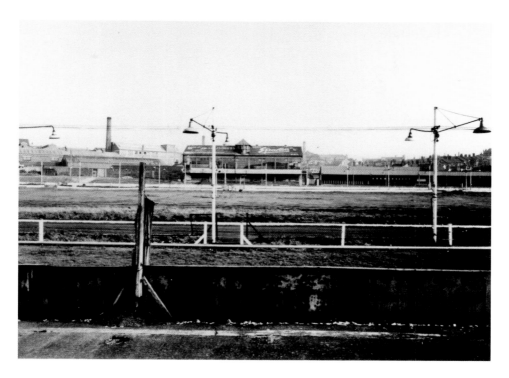

Sun Street Stadium, Early 1960s and Entrance, 1996
Near to the stadium was a red ash tip, from which many people would watch the speedway free of charge. This handy vantage point was known locally as 'Scotchman's Hill'. The speedway stadium closed in 1963 and afterwards the site was developed by A. E. Chatfield, the Ford dealer, formerly of Marsh Street. During building work, the company's engineers found 90-foot-deep marl holes and old mine shafts beneath the site.

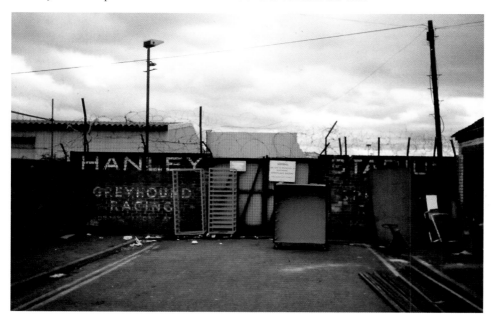

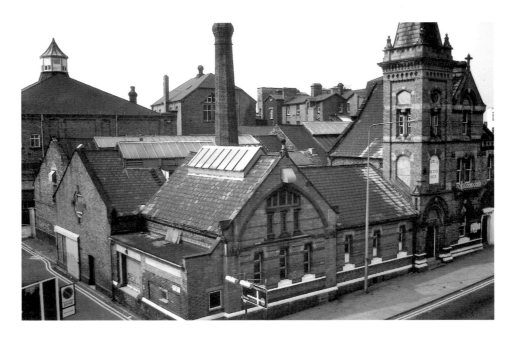

Hanley Baths, 1978 and Former Site, 2012

Ernest Warrillow's book, *Arnold Bennett and Stoke-on-Trent* reveals that the Hanley-born author learned to swim in Hanley Baths. It opened in 1873, though sex segregation was observed. A Turkish bath was incorporated and this was used by both men and women – but on separate days. At one time, people took their weekly bath at the venue, with the result that on some Saturday nights, the water was so murky that it was difficult to see the tiles on the bottom.

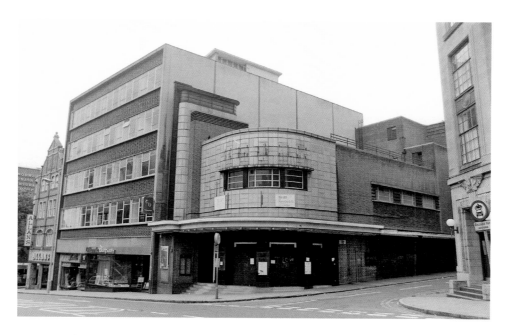

Former Odeon, 1970s and Revolution, 2012
The Art Deco Odeon Cinema in Trinity Street opened in 1937, launching the Odeon Cinema Club for boys and girls in 1943. It met on Saturday mornings and was part of a national movement to raise the standards of citizenship by showing the right kind of films to children. The cinema closed in 1975. The front part of the building became the Foyer, a café-bar and restaurant, in 1994.

Library and Museum, 1975 and Pall Mall, 2012

The original Potteries Mechanics' Institute was founded in 1825. It opened a base in Frederick Street in 1835 and accommodated travelling exhibitions. In 1844, patrons could see mechanical waxwork figures depicting the Royal family, Androcles and the Lion and the death of Napoleon. The building with the Ionic columns opened as the town's new Mechanics' Institute and reading room in 1861, housing a museum in its upper story. A new museum and art gallery was opened in Broad Street in 1956.

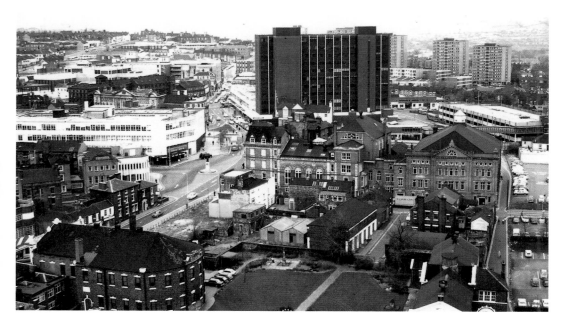

Town Hall and Victoria Hall from Top of Unity House, 1982 and Victoria Hall, 1996
The Victoria Hall has had a kaleidoscopic history since its opening in 1888. In 1952 it welcomed Gracie Fields, who performed in the Potteries for the final time, aged fifty-four. The Rochdale-born vocalist sang 'Sally', 'Sing As We Go', 'Wish Me Luck As You Wave Me Goodbye' and other favourites before an audience of 2,500. Mountaineer Sir Edmund Hillary, who conquered Everest in 1953, also visited, giving a lecture on the subject at the Victoria Hall a few months afterwards.

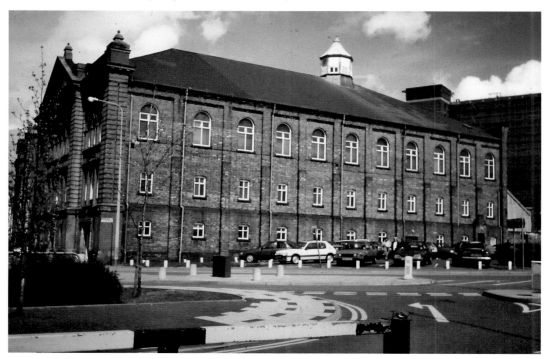

Theatre Royal, 1998 and 2001

Paul Wood became the Theatre Royal's stage doorkeeper in 1993. In the bottom photograph he is being interviewed by Radio Stoke's Sam Plank about the Royal's closure. The top picture relates to the planning of the 1998/99 pantomime, *Robin Hood & His Merry Men*, starring Syd Little and Eddie Large. The press launch was much earlier, to encourage ticket sales. However, when Eddie failed to appear, Paul suggested that, being the same build as Eddie, he might body-double for him. He was quickly told to pull his panto costume on. Paul recalls, 'They photographed the two of us, and superimposed Eddie's head on my shoulders on every poster. The image you saw of Little and Large was in fact Little and Wood, with Large's head attached in post-production.'

Theatre Royal Cod Panto, *c.* 1993 and Closure, 2001

Paul Wood co-wrote a number of cod pantos that were staged in the Theatre Royal bar. The theatre – rebuilt in 1951 following a disastrous fire in 1949 – closed in 2001, its stage having been trodden by such names as Gracie Fields, George Formby, the Sadlers Wells Theatre Ballet, Laurel and Hardy and the evergreen Ken Dodd. Betty Driver – later to find fame as Betty Turpin in Coronation Street – was principal boy in the 1940 panto at the theatre.

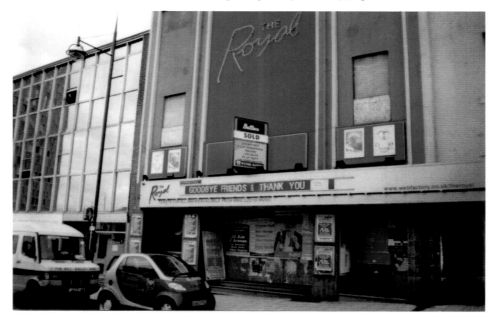

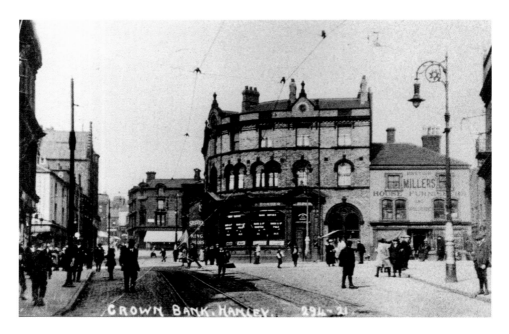

Dolphin Hotel, Crown Bank, Early Twentieth Century and Superloo, 2012

Our Hanley pub crawl begins at the Dolphin, which stood in Stafford Street, overlooking Crown Bank. The picture shows Miller's House Furnishers and Upholsterers, immediately to its right, established in 1840. This later became Capper's Ltd, the grocers, and later still, George Mason's family grocers. To the right of that was Market Lane and another pub, the Marquis of Granby. These buildings were demolished long ago. The present Superloo on Crown Bank was opened in 1988.

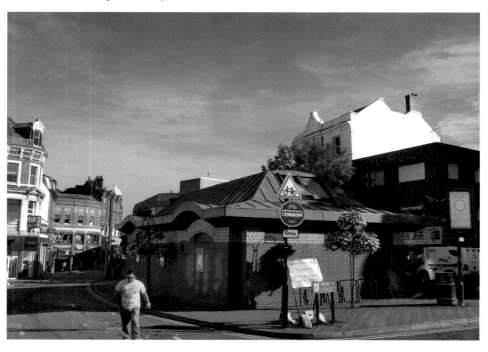

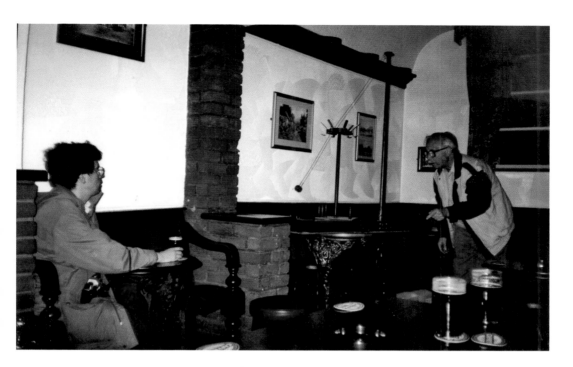

Coachmakers Arms, 1997 and 2008

This pub originally operated as a beer house from about 1870. Our interior photograph shows David Lycett and Ken Smith playing bar skittles. Described in the *Stoke-on-Trent City Centre Magazine & Guide* (2008) as 'a little gem for Stoke-on-Trent to be proud of', the pub was to face a threat to its existence shortly afterwards. The banner above the pub in 2008 highlighted the campaign to save it from being demolished as part of City Centre redevelopment plans.

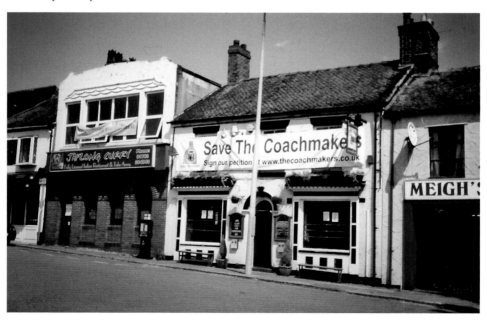

Globe, Late 1920s and Interior, 1993
The top photo shows Louis Cartlidge and Myra (*née* Daniels) Cartlidge at the rear of the Globe public house in Bucknall New Road. Barry Cartlidge, who was born in the pub, told the *Sentinel* in 2011, 'When I was a kid we used to have to take beer to people who wanted to drink in their home, usually elderly people who couldn't come out.'
The gable end of the pub boasted tie-bars, protecting against mining subsidence. Old maps show the proximity of the Northwood Colliery, the Ivy House Colliery and the Dresden Colliery. This fine community pub embraced a bar on the left and a comfortable lounge on the right, enjoyed here by Laura Butler, Ann Dutton and Andrew Dutton.

Globe, Late 1920s and Dave Nullis, 1998

Another picture of the happy couple is followed by a photograph of Dave Nullis. He took over the tenancy in mid-1994, having been a miner at Florence Colliery from 1977–93. Those who knew the Globe during Dave's time will recall that a game called Cardo – a variation of Bingo, using playing cards and bottle-tops – was played on Saturday nights. Burtonwood Top Hat (4.8 per cent) sold well at the Globe in this period.

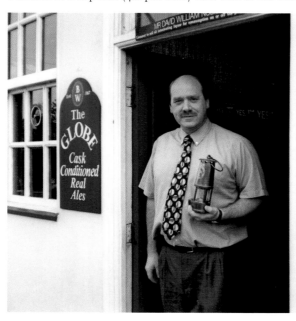

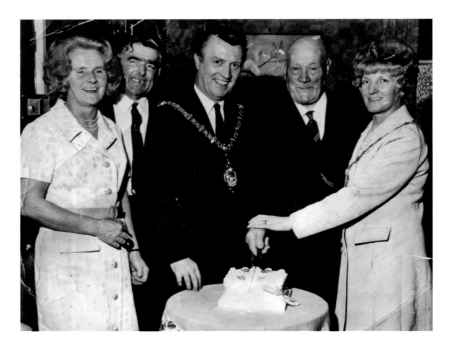

Globe, 1971 and Awaiting Demolition, 2010

This celebration shows, from left to right: Mr and Mrs Morgan, the licensees; the Lord Mayor of Stoke-on-Trent, Harry Barlow, who was marking his ninetieth birthday; and the Lady Mayoress. There was nothing to celebrate in March 2009 when the Globe closed forever on account of its being in Renew North Staffordshire's clearance area. The last licensees were Amanda Richardson and Craig Johnson. The building was targeted by arsonists in June before being demolished in the summer of 2011.

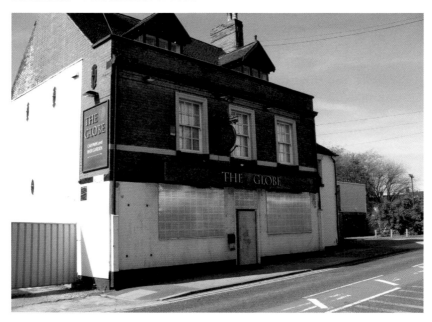

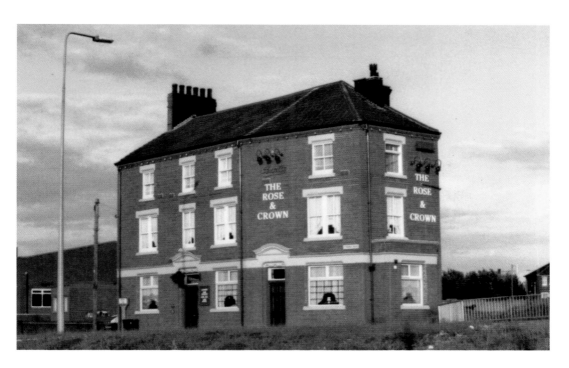

Rose & Crown, c. 1981 and Offices, 2012

A former Parker's Burslem Brewery pub remembered for its coal fires, this was the CAMRA Potteries branch Pub of the Year in 1985. Many drinkers will recall the landlord, Rob Ward, a bus enthusiast who managed to purchase a 1956 Bristol Lowdecker in 1991. For a while, this stood to one side of his pub. The Rose & Crown has been used as offices since 1998.

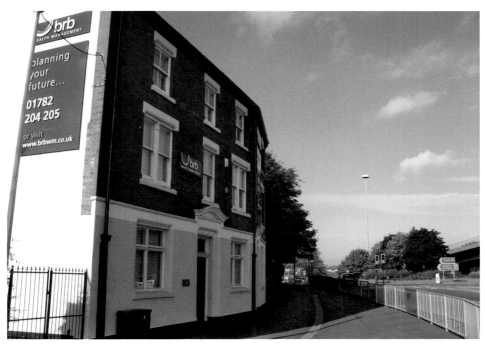

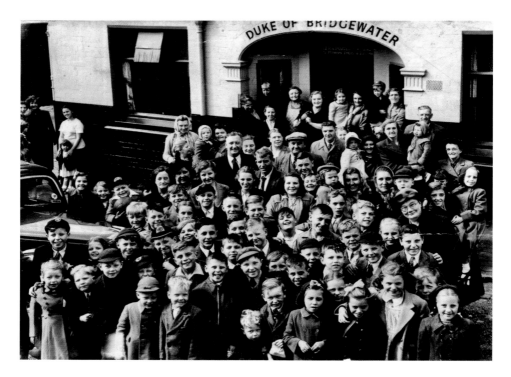

Duke of Bridgewater, Etruria Vale, c. 1950 and 2000

A crowd has gathered outside the Duke for a social event – probably a day-trip – around 1950. Dead-centre in the photograph is Alec Ormston, the Stoke City player. The pub's name recalls Francis, the 3rd Duke of Bridgewater (1736–1803), an industrialist and a fervent promoter of canals. Its proximity to the nearby inland waterways often saw it being advertised in the regularly produced guide books of the Caldon Canal Society.

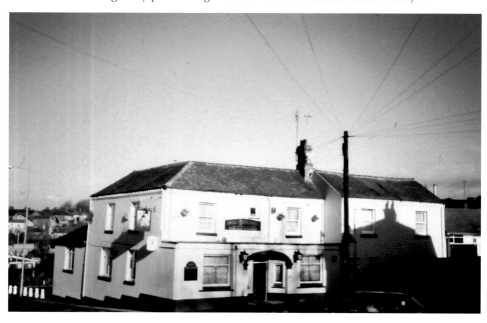

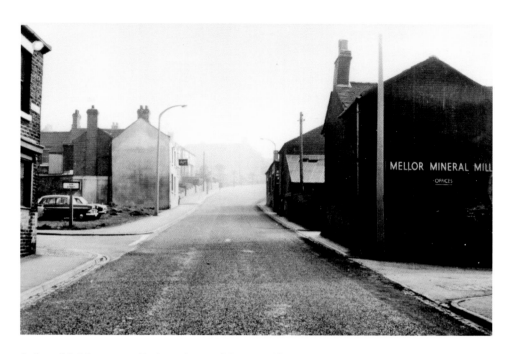

Duke of Bridgewater, Early 1960s and Former Site, 2012
The pub had a strong darts team in the 1980s, but was demolished in August 2005. The company of Mellor Mineral Mills Ltd was formed in 1792 and incorporated in 1922. It produced raw materials for the pottery industry. By 1971 the company announced that it was 'now engaged, in addition to its connections with the pottery industry, in dry grinding refractories and calcining and grading of flints'.

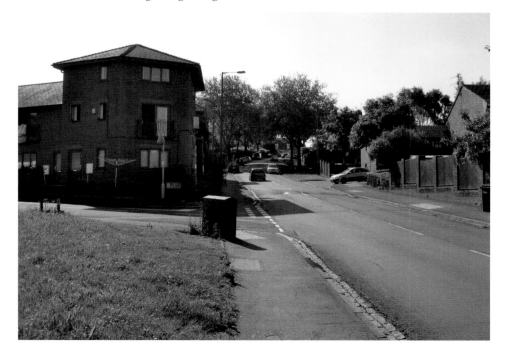

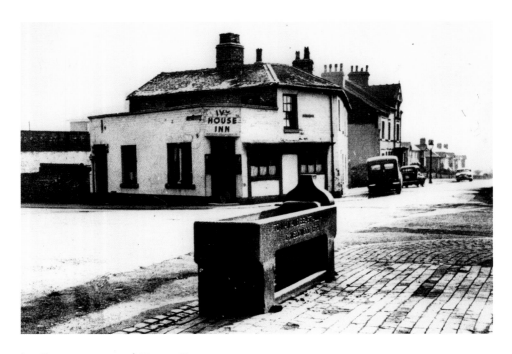

Ivy House, 1950s and Mango Tree, 2012

In the 1950s, the old Ivy House pub building in Bucknall New Road, seen here, was replaced by a brand-new building, built just behind it. During the transition the pub never closed, the new one being opened the day after its predecessor shut. The licensee at the time was Bill Grundy. The Ivy House became the Mango Tree in 2006. The horse trough is inscribed, 'To Man and Beast All Akin. G. Wedgwood, 1879.'

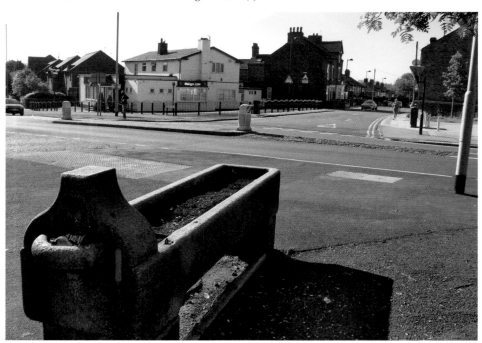

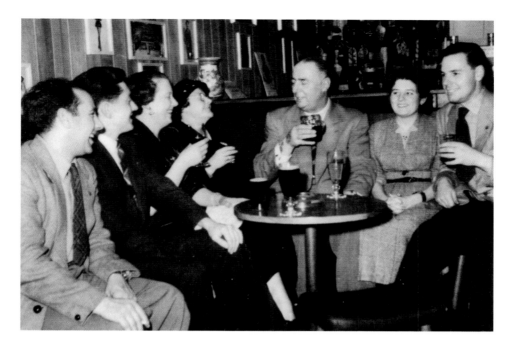

Mechanics Inn, 1950s and Stage Door, 1994

Ken Smith, a friend of the author, recalls the Mechanics Inn in the early 1950s when it was virtually collapsing. 'When you went into the bar,' recalls Ken, 'there was quite a large crack across the floor from the fireplace, and you could see it growing larger and wider each time you went in! There was a pillar at the bar that stood at a fifteen-degree angle, so the pub was obviously on its way out.' Subsidence led to the Mechanics being rebuilt in 1957–8. It is now the Stage Door, seen from Brunswick Street in the bottom photograph. The pub stood right opposite the stage door of the Theatre Royal, hence the name.

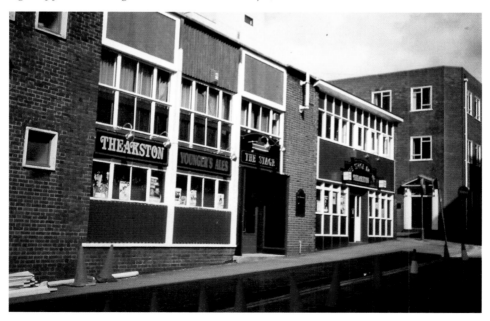

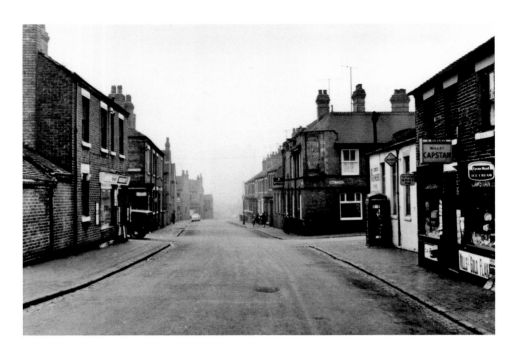

Shoulder of Mutton, Early 1960s and 2011

The Shoulder of Mutton stands on the corner of Sun Street and Mount Pleasant, its name – complete with a full stop – highlighted in relief letters on a terracotta background on the frontage. An early-twentieth-century photograph shows one of the windows on its Mount Pleasant side advertising Worthington's Pale Ale. Though closed at the time of our colour photograph, it reopened in 2012, advertising traditional ales and its beer garden, located to the rear.

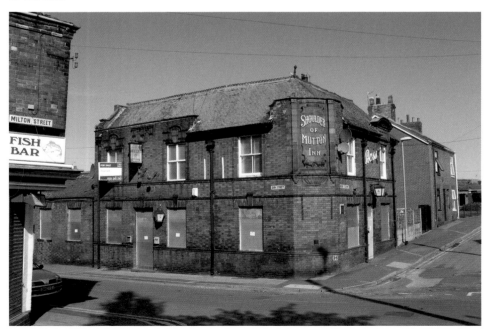

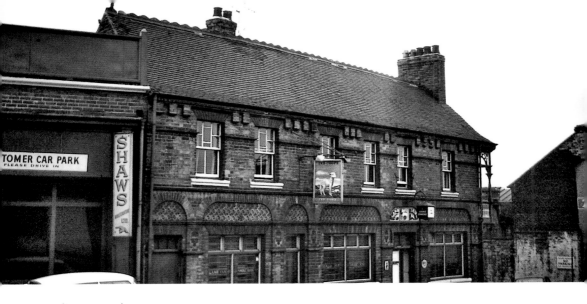

Lamb, 1971 and 1994
The Lamb in Marsh Street stood opposite the site of the old Tesco store in New Hall Street. Ken Cubley, who supplied the older photograph, recalls that Tildsley's pawnbrokers stood on the right of the building. Its frontage incorporated a lamb motif and the date of 1892. It was later relaunched as the Zoo, but was afterwards demolished.

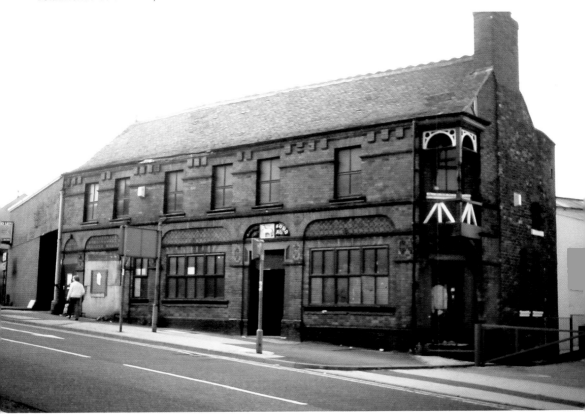

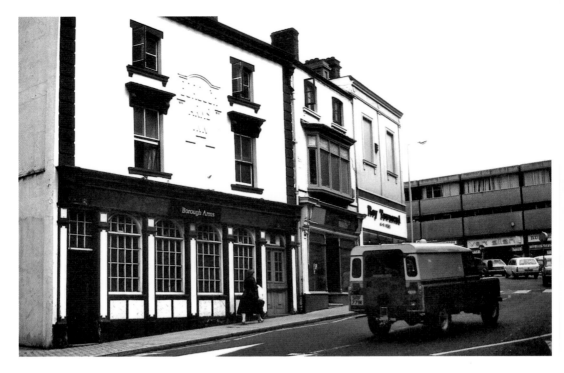

Borough Arms, 1970s and O'Neill's, 1995

Here's another pub remembered by Ken Smith, who knew it in the 1950s. 'At the top of the street,' he recalls, 'was the modern Borough Hotel (known as the 'Big Borough'). Down the street was the Borough Arms (the 'Little Borough'), a tiny, two-room pub, and a place full of knick-knacks – pottery, stuffed birds, etc. It was also a local call for the ladies of the night, whose patch was Trinity Street, Marsh Street and Foundry Street.'

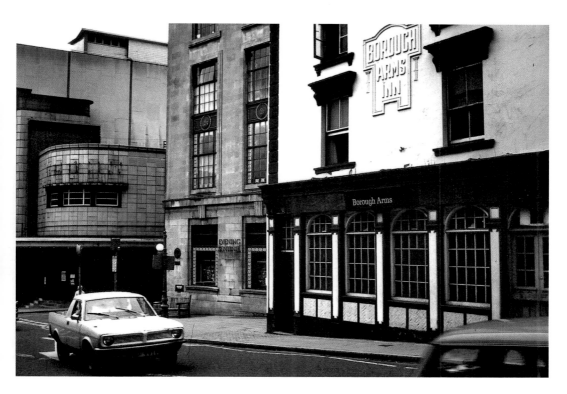

Borough Arms, 1970s and O'Neill's, 1996
By the 1990s, the Borough Arms rejoiced in the name of Leadbelly's, before embracing the fad that saw Irish-themed pubs sprouting up in English towns and cities. The Woodman in Old Hall Street became Scruffy Murphy's and O'Brien's Post Office in 1994, while this hostelry became O'Neill's and MacNamara's Music Bar. In 2012, it was trading as Base.

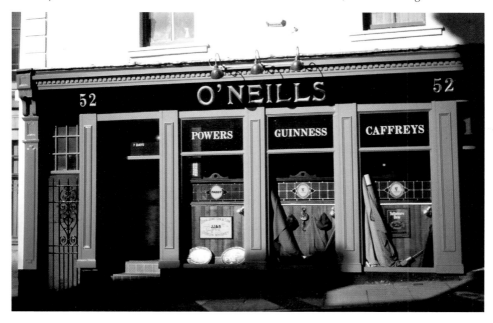

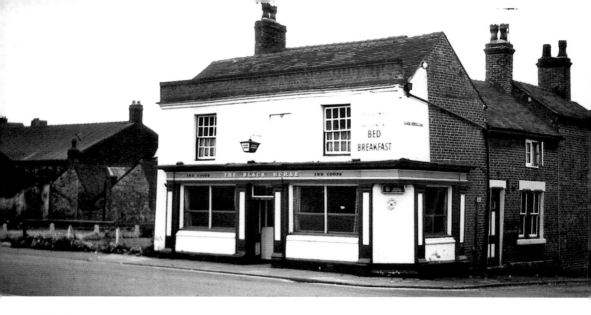

Black Horse, 1971 and 1994

The Black Horse in Marsh Street was tenanted between 1974 and 1980 by Len and Carol Battisson. They ran yard-of-ale drinking competitions, started a pub football team and even ran a bed and breakfast service. This bikers' pub closed in July 1991, after Ansells Brewery had decided not to spend money on bringing it up to health standards. The last licensee was Kath Cotterill. Demolition took place at the end of 1994.

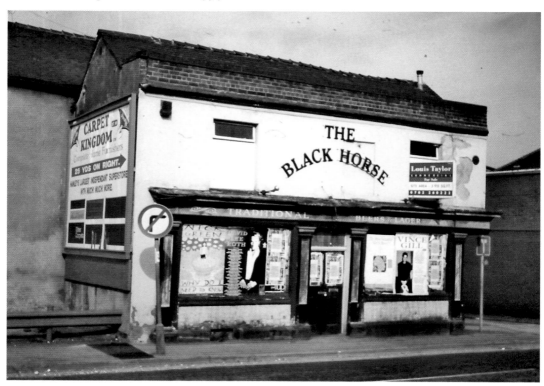

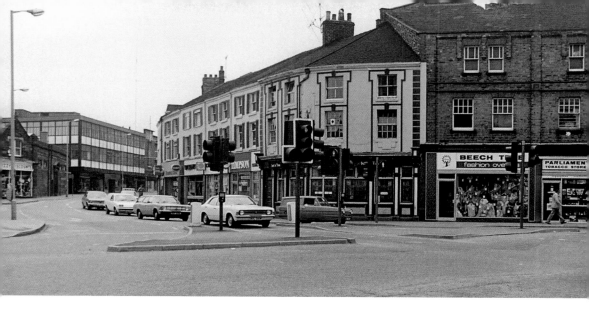

Just in Time, 1970s and Franky's Bar, 2012

This pub, on the corner of Parliament Row and Old Hall Street, once faced Hanley's old fire station which opened in 1921 on the corner of Percy Street. The hostelry is remembered with affection as the Just in Time, but has had a number of names since, including the Corner House and the Five Towns. It is a short distance from the Burton Stores.

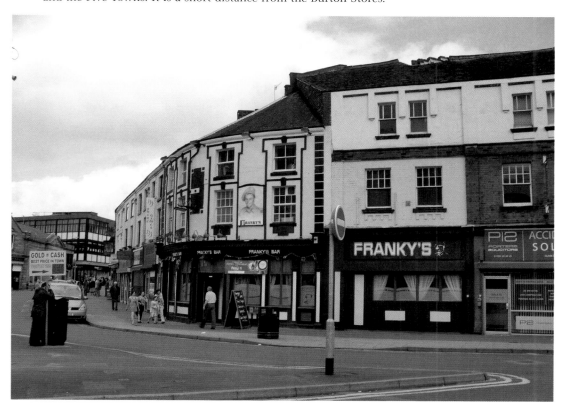

Grapes' Demolition, 1971 and Co-operative Bank, 2012

Earlier photographs reveal the full architectural majesty of the façades of the Angel and the Grapes, both of which suffered insensitive alterations in the 1960s. The handsome brick frontage of the Grapes was given a ceramic tiled 'make-over', as seen here. The pub had formerly been known to locals as 'Wilders'. It was a sad day on 25 August 1971 when the *Evening Sentinel* carried a front page photograph of both the Angel and the Grapes being demolished.

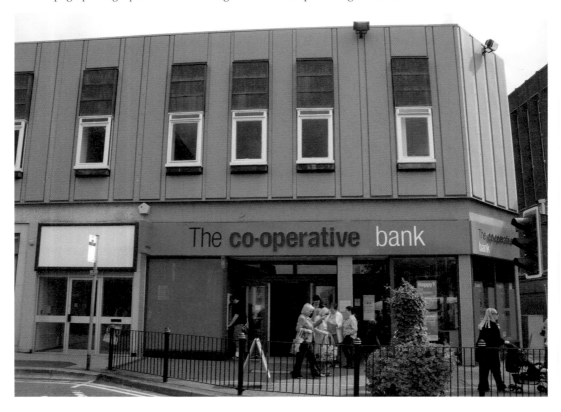

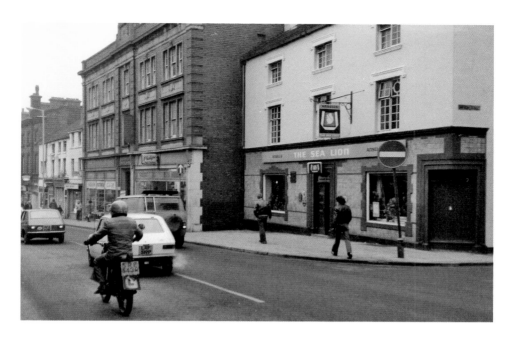

Sea Lion, 1970s and Town Road, 2012

The Sea Lion stood on the corner of Empson Street and Town Road. Its proximity to St John's church led to vestry meetings being held at the Sea Lion – hence its one-time nickname of the 'Church House'. Attractions from Batty's Circus sometimes appeared on the pub's bowling green, next to St John's. A surviving *Sentinel* photograph shows the pub being demolished in 1980. The Potteries Shopping Centre now occupies part of the old site.

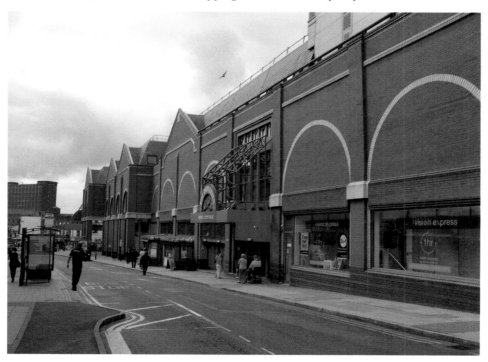

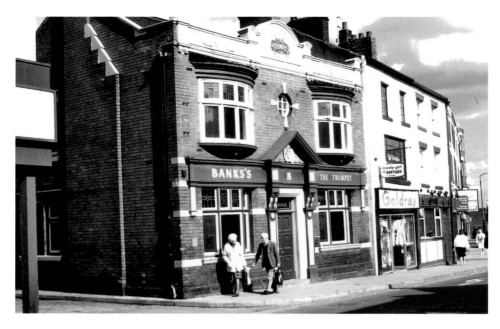

Trumpet, 1985 (Now the Site of McDonalds) and Parliament Row, 2012
According to CAMRA's Real Ale in the Potteries (1984), the Trumpet's glories had faded prior to its eventual demolition: 'Revamped town tavern, three rooms having been knocked into a through lounge, sadly for the worse.' Fred Smith of Fenton wrote to the *Sentinel* in July 2012, revealing that he had been responsible for demolishing the Angel, the Grapes and the Trumpet – whose front entrance was later incorporated in a building at Les Oaks' farm at Cheadle.

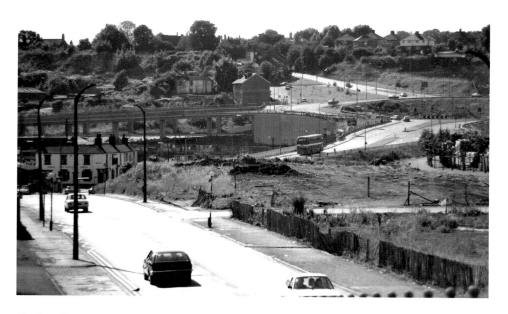

Shelton from Etruria Old Road, 1970s and Holy Inadequate, 2012

Here's a pub that originated as the Railway Inn. It had many associations with iron and steel making at Shelton Bar. Around the year 1900, molten slag from the furnaces was hauled by horses. Horses and men alike were sometimes scalded by hot metal when it was dislodged in the ladles. Men were sometimes taken to the North Staffordshire Infirmary to receive attention. If badly hurt, patients would be handed a brandy, purchased from the Railway Inn.

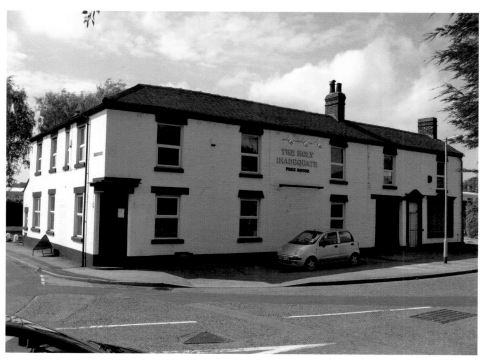

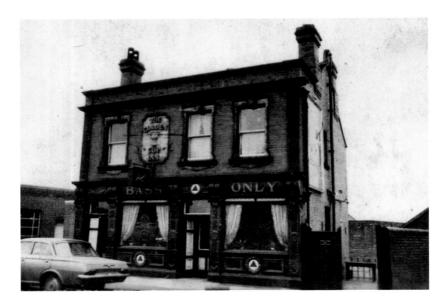

Golden Cup, *c.* 1960 and 2012

The Golden Cup, in Old Town Road, became a Grade II listed building in 2008. It is not difficult to see why. Its dark-green, faience-tiled façade was probably manufactured by a local company, while CAMRA research suggests that the Bass Only tiling is unique. It is an excellent example of the aggressive advertising deployed by the major breweries in the early twentieth century. In 1964, the pub frontage was altered, with the central doorway replaced by a window.

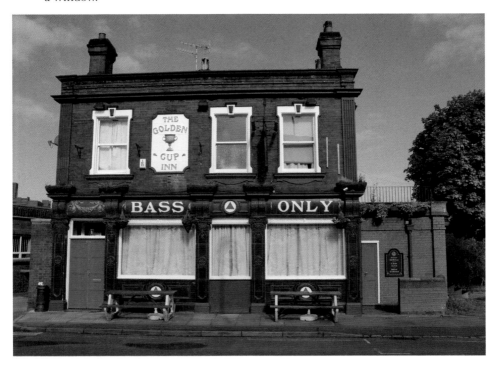

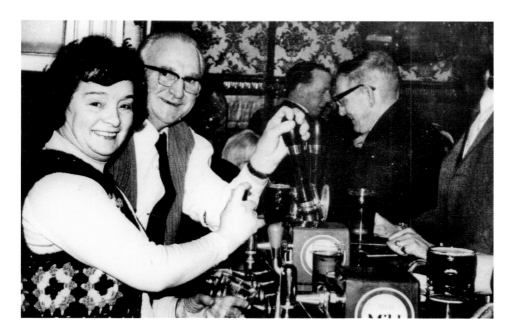

Betty Buckley and Ernie Sharman at the Golden Cup, *c.* 1970 and Customers, 1998
Betty and Ken Buckley, who were married in 1939, came to the Golden Cup in 1952. They had difficulty in unloading a piano from a furniture removals van, but were helped by a Baxter's bus driver, Ernie Sharman, who stopped his bus and assisted. He later became a friend, customer and barman. Ken would often place plates of free pig-pudding, bread, cheese and pickles on the bar for hungry workers. The colour photograph shows Dawn Tatler and friends.

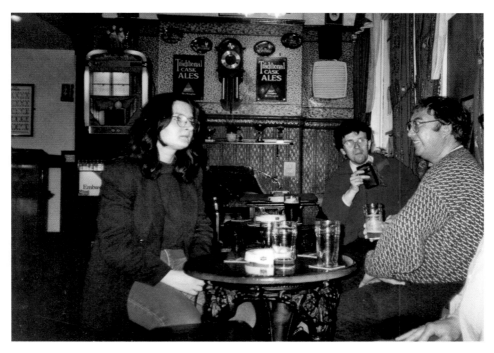

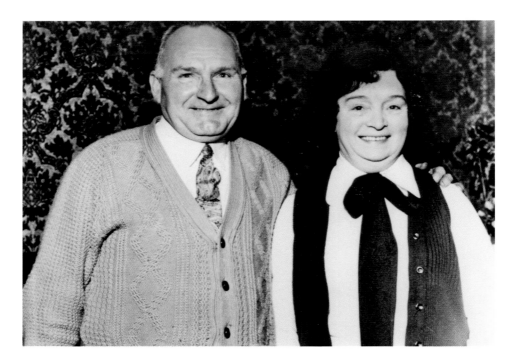

Ken and Betty Buckley, *c.* 1970, Customers in 2003 and Ken Buckley Junior (inset), 2012
Betty's son, Ken, recalls the pub's association with local industry: 'The local potters in our pub would make more mess than the colliers, and would sometimes come in with slip sticking to their shoes. This was no problem for mother, as she kept what was a working peoples' bar. She was more protective of our smoke room. If men were wearing overalls and sitting on a nice chair, she'd ask them use the bar until they had changed their clothes.'

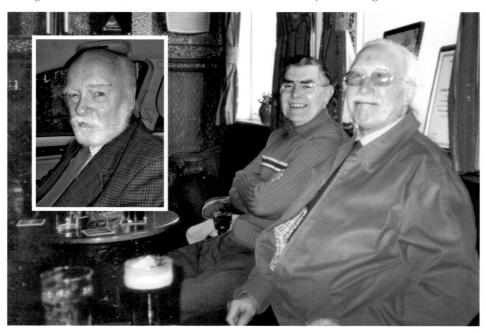

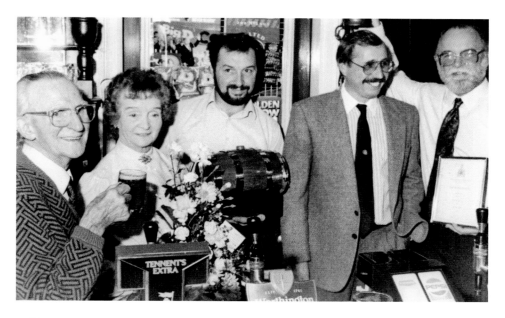

Golden Cup CAMRA Presentation, 1980 and PPPG Presentation, 2012

The 1980 presentation shows Ernie Sharman (barman), Betty Buckley (licensee), her son Roy Buckley, Dave Washbrook (CAMRA, Potteries) and Ken Junior. The barrel was presented by Betty. Its inscription reads, 'Presented to CAMRA Association 1st July 1980 by Mrs Betty Buckley (Licensee) Golden Cup Inn, Town Road, Hanley, for their dedication to the preservation and consumption of Real Ale.' The pub was also the first winner of the Potteries Pub Preservation Group's Community Pub of the Year in 1998.

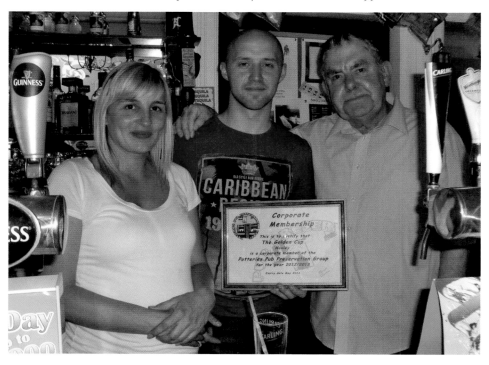

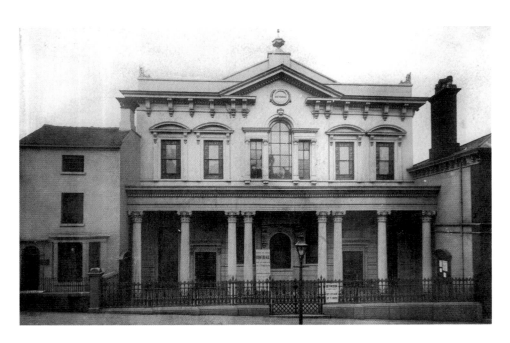

Bethesda Chapel, Date Unknown and 2012

Following are photographs relating to Hanley's ecclesiastical history. The beautiful Bethesda chapel closed in 1985. Discussions for its conversion into a religious museum were held in 1989, while plans for a restaurant and disco were rejected in early 1991. Efforts to repair Bethesda received national publicity when it featured in BBC2's series *Restoration!* in 2003. Since then, the 'Cathedral of Methodism' has been restored almost to its former glory and has received visitors from all over the world.

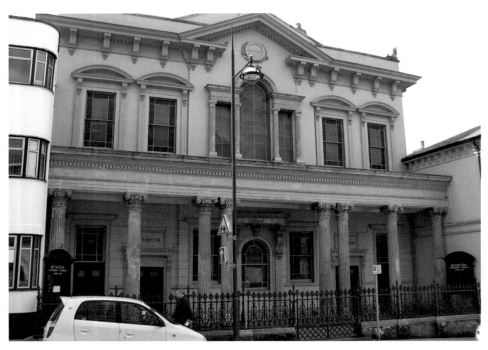

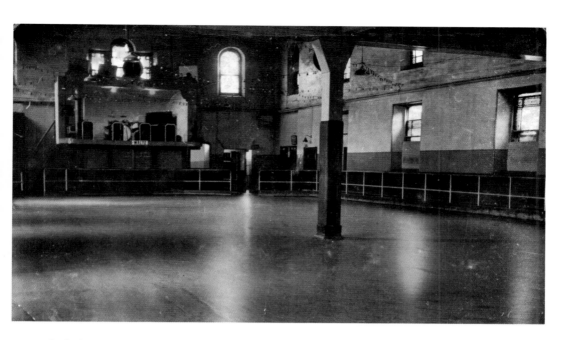

Ideal Skating Rink, Date Unknown and Town Road, 2012

The old Tabernacle chapel in Town Road later saw use as a billiard hall and then a roller-skating rink from 1930. It also offered wrestling on Monday nights and dancing. Numerous tumbles on the skating rink – many of them deliberately engineered – led to romance and marriage. Mrs Joyce Daley is remembered as the rink's MC. An excellent skater herself, she blew her whistle to warn lads who were becoming too rowdy. The Ideal closed in the 1970s.

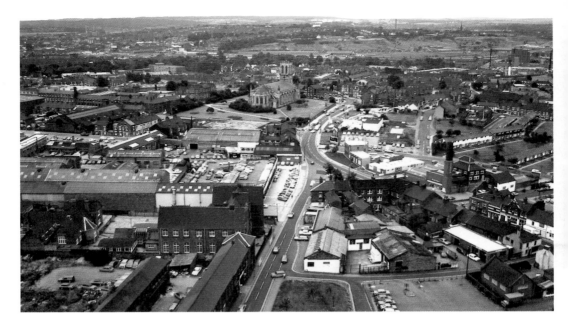

St Mark's from the Top of Unity House, 1982 and in 1996
St Mark's church in Shelton was consecrated in 1834, the work of John Oates of Halifax – who did not live to see his work completed – and Thomas Pickersgill of York. It was designed to accommodate 2,100 worshippers and is said to be the largest church in the Potteries. The original square-ended chancel was replaced by an apsidal chancel by R. Scrivener and Sons in 1866. Memorials in St Mark's recall potters Joshua Twyford (1640–1729) and Thomas William Twyford (1849–1921).

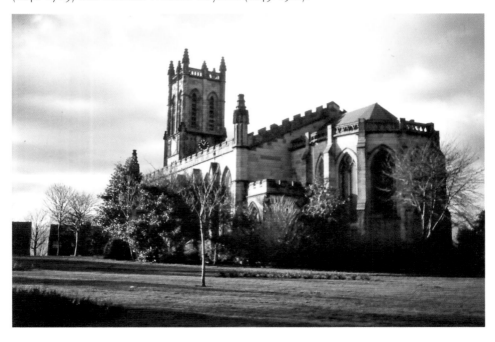

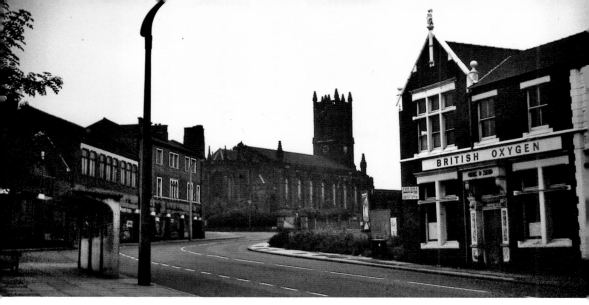

St Mark's from Foot of Broad Street, 1971 and Church Tower, 2001

In the 1950s, the Council's Parks and Cemeteries department landscaped a number of churchyards. The new 'beautified' gardens around St Mark's were officially declared open in 1956. The church was formerly blackened by smoke but in 1974 the stonework was cleaned. Father Leonard Skinner produced a book, *Shelton and Its Church*, to recognise St Mark's 150th anniversary. In 1996, a memorial tablet to those from Shelton and Etruria who died in the Second World War was dedicated and placed in the porch beneath the First World War plaque. In recent years, the church has undergone an internal renovation. The west tower is 120 feet high.

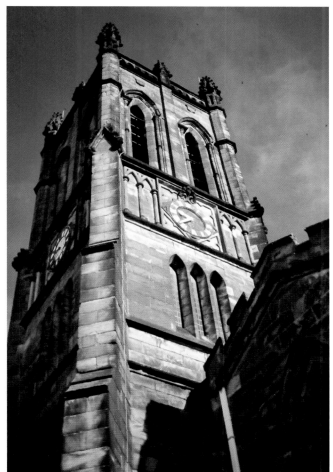

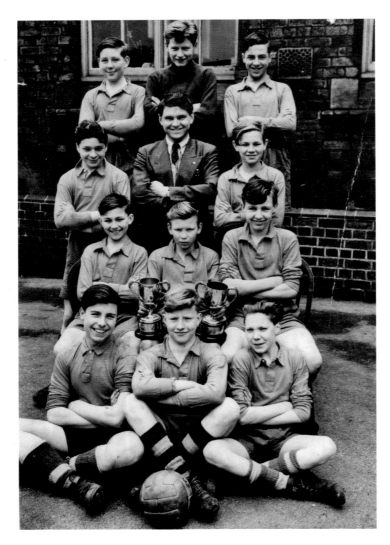

Cannon Street Senior School Intermediate Football Team, 1952/53 If school days were the happiest days of our lives, it is perhaps appropriate to end with a school photograph. The school teacher is Mr Harrison, the sports master. Left of him is John Massey, and on the right, Howard Gorton. Below Harrison is John Ford, and on the right of him as we look is Graham Lowe.

Acknowledgements

Ken and Graham Cubley (especially), as well as: Celia Abbotts, Robert Adams, Barewall Art Gallery, John Booth, Kevin Breward, Kevin Broad, Francis Brooks, Ken Buckley, CAMRA (Potteries branch), Sheila Carter, Barry Cartlidge, Bryan Deane, the Dudson Museum, Ann Dutton, Jim and Pam Dutton, Ken Edwards, Pat Foster, Marie Haywood, Glyn Kelsall, Alan Myatt, Pauline Rowley, the *Sentinel* newspaper and John Abberley, Ken Smith, Gary Tudor, Alan White, Paul Wood, Jim Worgan.

Much caption information was personally supplied by the above people. Readers are asked to allow for minor errors of memory.